IMAGES
of America
BOSTON'S
FORT POINT DISTRICT

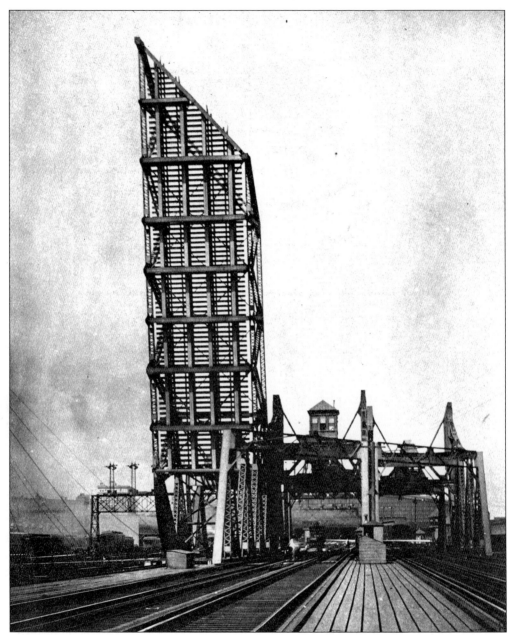
The west leaf of the new New York, New Haven & Hartford (Old Colony) Railroad Bridge over Fort Point Channel is raised for trial testing in 1899.

IMAGES of America
BOSTON'S FORT POINT DISTRICT

Michael J. Tyrrell

Copyright © 2004 by Michael J. Tyrrell
ISBN 0-7385-3533-8

First published 2003

Published by Arcadia Publishing
Charleston SC, Chicago IL, Portsmouth NH, San Francisco CA

Printed in Great Britain

Library of Congress Catalog Card Number: 2003117075

For all general information, contact Arcadia Publishing:
Telephone 843-853-2070
Fax 843-853-0044
E-mail sales@arcadiapublishing.com
For customer service and orders:
Toll-free 1-888-313-2665

Visit us on the Internet at www.arcadiapublishing.com

In memory of my late father-in-law, Diniz I. Vieira.

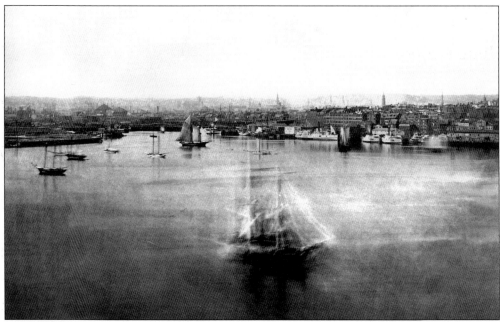

This 1877 view from East Boston looks southward across Boston Harbor toward the mouth of the Fort Point Channel. Although smaller sailing sloops were more commonly seen here, large square-rigged vessels also plied these waters. To the right, a side-wheel passenger steamer is docked at Rowes Wharf—the oldest continuously operating landing for passenger vessels in the United States. (Boston Public Library.)

CONTENTS

Acknowledgments		6
Introduction		7
1.	Topographic Origins	9
2.	Business, Industry, and Real Estate	19
3.	Bridging the Channel	49
4.	South Station and Dewey Square	73
5.	South Boston Piers Area	95
6.	Forging a Future: The Recent Past	109

ACKNOWLEDGMENTS

This book celebrates the dedication and activism of the scores of individuals who recognize their critical and timely role in preserving Fort Point's rich past while shaping its future. I would like to thank the following for their support: Albert Rex and Douglas Terpstra of the Boston Preservation Alliance, Aaron Schmidt of the Boston Public Library Print Department, Sally Pierce of the Boston Athenaeum, and Nancy Richard of the Bostonian Society. Thanks also go to Ginger Yowell of the Society for the Preservation of New England Antiquities, Kristin Swett of the Boston City Archives, John Cronin of the Boston Herald Library Archives, author Nancy Seasholes, Jon Roll of Jon Roll Associates, and Steve Hollinger of the Seaport Alliance for a Neighborhood Design. Special thanks go to Steven Nutter for his generous graphic design assistance; Paul Farrell, AIA, for his allied efforts to preserve the Old Northern Avenue Bridge; and Kathy Chapman for her insightful memories of Fort Point's early art-colony years. Finally, I thank Kaia Motter at Arcadia Publishing for her encouragement and my dear wife, Sandra M. Vieira, whose love and support drove this book to completion.

—Michael J. Tyrrell
Worcester Square, Boston, Massachusetts

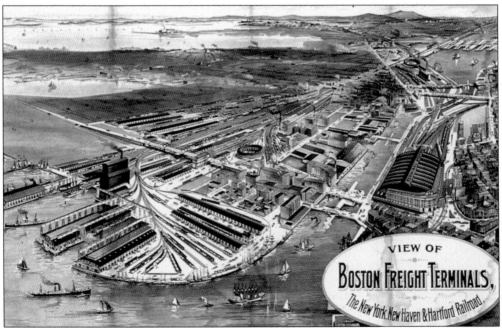

Boston's Fort Point District played a leading role in the distribution of New England products to western cities by rail and to South American and European ports by sea. The Boston & Albany and New York, New Haven & Hartford Railroads were the area's principal rail landholders. This promotional poster from 1899 depicts the extent of their waterside holdings. Note the Fan Pier in the foreground, with its unique pattern of freight rail sidings. (Athanas family.)

INTRODUCTION

Boston's Fort Point District derives its name from the Fort Point Channel running alongside it. Originally a wide saltwater inlet, the channel linked Boston Harbor and the South Bay, separating the Shawmut Peninsula from the tidal mud flats that lay off of Mattapanock, or Dorchester Neck. The channel was named for Fort Point, near today's Rowes Wharf where Fort Hill and the Colonial fortifications known as the South Battery were situated and where the International Place towers stand today. As Boston grew, Fort Hill was leveled to fill the coves on either side. Although there were wharves along the Boston side of the South Bay, Dorchester Neck was sparsely settled during the Colonial period.

In 1804, the state legislature annexed Dorchester Neck to Boston and authorized new bridges to link the two areas. The South Boston Bridge opened in 1805, and the North Free Bridge opened in 1826 on the site of today's Dorchester Avenue Bridge. These bridges allowed industries, such as glassmaking, shipbuilding, and iron making, to grow in South Boston. Industrialist Cyrus Alger filled the flats off of today's Foundry Street and built wharves and buildings for his company, the South Boston Iron Works. Other industries followed Alger's lead.

On the opposite side of the channel, in 1833, a group called the South Cove Associates formed to fill the cove and provide land for a station and rail yard for the Boston & Worcester Railroad. Part of this land is today's Chinatown. Wharves were built on the channel along the edge of the filled land, forming part of the west side of the channel.

In 1836, responding to strong demand for new wharf space in Boston, a group of shipowners founded the Boston Wharf Company. The company began to fill the Dorchester mud flats and form the channel, initiating an effort that continued for more than 50 years. The company built two stone wharves, forming three docks. Today's A Street, originally named Granite Street, ran along the eastern wharf. The company used the new wharves primarily to store sugar and molasses for the city's sugar refineries. The company filled additional land along its north and east sides in the 1850s to attract railroad spurs to its land.

Two new bridges opened in 1855. The Mount Washington Street Bridge connected the Boston Wharf Company wharves to Kneeland Street in Boston. The Eastern Railroad Bridge brought the New York & New England Railroad across the channel in a circular sweep to the foot of Summer Street in Boston. Soon, more bridges spanned the channel. The Broadway Bridge came in 1871, followed by the original Congress Street Bridge in 1874. Next, in 1877, came the West Fourth Street Drawbridge to replace the Dover Street Bridge, itself a successor to the 1805 South Boston Bridge. The Northern Avenue Bridge, over the mouth of the channel, was built in 1908.

In 1896, the railroad companies with lines running south of Boston incorporated the Boston Terminal Company. The costs of maintaining individual lines escalated, and a single *union* station on the model of North Station helped reduce each company's expenses. South Station opened to the public in January 1899 and quickly became the busiest station in the country. With the completion of the South Station rail yards in 1898, the Fort Point Channel had attained its present form.

The docks and wharves in the South Bay along the channel and eventually along the harbor created a tremendous amount of waterfront activity. By 1880, the Boston Wharf Company had 17 sheds for the storage of imported sugar and molasses.

Beginning in 1883, however, the refineries they served began to import and store their own raw materials. To compensate for the loss of revenue, the Boston Wharf Company began to use its land to generate income from real-estate activities. The company constructed buildings along Congress Street, the first of these identified at 321–327 Congress Street. Some wharf buildings were rented to tenants, and others were sold to commercial and industrial concerns.

The activity from these buildings, in addition to that from Fan Pier and the other docks, increased traffic on Congress Street so much that in 1896, the extension of Summer Street into South Boston was authorized. With the completion of South Station, the Eastern Railroad Bridge was no longer needed and, in 1899, was replaced with the Summer Street Bridge. Many wool merchants moved across the channel from Dewey Square to the new wool warehouses and offices that the Boston Wharf Company constructed for them along Summer Street. By 1930, the district had become the center of the wool trade in the United States. Morton D. Safford and Howard B. Presscott, staff architects of the Boston Wharf Company, designed most of the company's buildings.

In 1900, the Fort Point Channel was lined with wharves where ships unloaded or transferred coal, lumber, bricks, cement, leather, ice, sugar, iron, machinery, and beer, among other items. However, the activity in the channel had begun to decline by the mid-20th century due in no small part to the number of bridges that ships had to pass to reach the wharves. As many as eight bridges at one time crossed the channel. Ship captains had to use all their skill to navigate to their destination and were charged a fee for each bridge they had to pass, driving up their costs. Also, each time a bridge was opened, all land traffic across that bridge had to stop.

As early as 1868, legislative committees were recommending that the South Bay and Fort Point Channel be completely filled. By 1916, the bay's southeast flats were filled for industry and rail yards. In 1948, the Dorchester Avenue Bridge was fixed in place, ending ship traffic below that point. By 1955, the bay was almost entirely filled to accommodate construction of the Southeast Expressway—although a small remnant channel remained open into the late 1960s. As the shipping activity ceased, nonmaritime uses moved into the area. In 1963, the Gillette plant replaced the American Sugar Refinery. The U.S. Postal Service built its regional headquarters between the channel and South Station. The channel became an ill-regarded backwater, leading to a deficiency of maintenance.

In the mid-1970s, a group of artists displaced by a fire at the Plante Shoe Factory in Jamaica Plain moved to the Fort Point area, settling on Farnsworth Street. An influx of artists followed, all seeking the abundant, affordable space available in Fort Point's sturdy timber-and-masonry buildings. By 1980, an artist community had formed to promote culture and artist causes. Also by this time, other tenants in Fort Point included small businesses, light industrial manufacturing, produce distributors, and storage facilities. Gillette Corporation continued to thrive and expand in its facility. Meanwhile, across the channel in Dewey Square, entire blocks were being demolished to accommodate new office towers.

In the 1980s, public works projects were planned for the area. While a Central Artery highway project tunneled through Boston's downtown, another underground connection tunneled from the Massachusetts Turnpike under the channel, the Fort Point district, and Boston Harbor to connect with Logan Airport. South Station was rescued from the wrecker's ball and completely renovated. Fort Point's proximity to downtown Boston invigorated private investment. During the economic boom of the 1990s, the entire South Boston waterfront quickly became identified as a development frontier.

The Boston Redevelopment Authority, completing public planning processes for the South Boston Waterfront in 1998, concluded that zoning and planning should manage the area's growth for two distinct functions: one, a Fort Point historic subdistrict evolving as a mixed-use neighborhood oriented to the channel; the other allowing for expansion of industrial concerns nearer the Reserve Channel.

Boston's Fort Point District remains today as an important modern-day example of architectural integrity and urban industrial and cultural expression. Highly worthy of landmark designation, Fort Point's distinctive wharf buildings, bridges, and sea walls serve as a well-preserved reminder of New England's industrial, mercantile, and maritime past. And Fort Point's role as a center for entrepreneurship and innovation can be sustained through the conservation of its contemporary art scene. Much of this history and hope is brought to life in the photographs that follow.

One
TOPOGRAPHIC ORIGINS

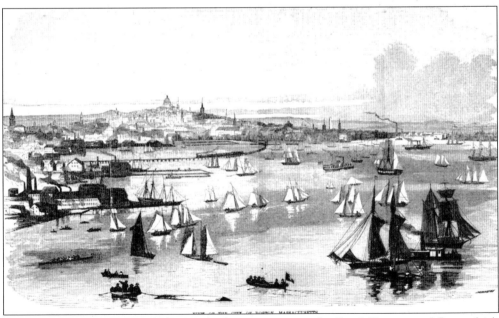

This westward view (c. 1845) depicts the busy waters over the South Boston mud flats at high tide. The area was soon to be transformed for industrial real estate through successive wharf building and landfilling. Note the passenger train leaving Boston over the Air Line railroad trestle. The wood-pile causeway afforded travelers arriving in Boston an impressive view of the harbor as they "flew" over the water into downtown.

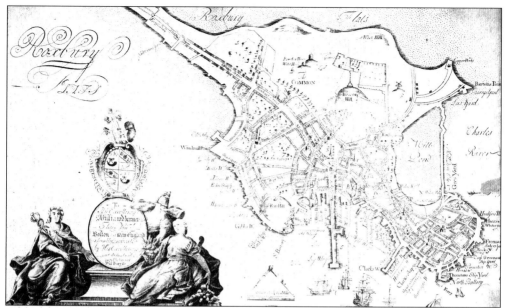

The 1728 Burges map of Boston depicts a growing settlement on the Shawmut Peninsula. Facing the harbor east of Long Wharf is Fort Hill, near which (in mariner's parlance) "Fort Point" became the primary landmark for ship captains navigating on a deep channel leading to the South Cove and farther to South Bay. Hence, the name Fort Point Channel. (Boston Public Library.)

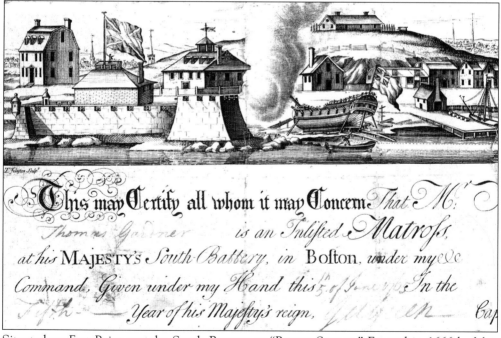

Situated on Fort Point was the South Battery, or "Boston Sconce." Erected in 1666 by Maj. Gen. John Leverett, the site is where the Rowes Wharf complex stands today. Fortresses like these dotted the shores of Boston Harbor but saw little or no military conflict. Note the shipyard to the right and the barracks on Fort Hill beyond. (Boston Athenaeum.)

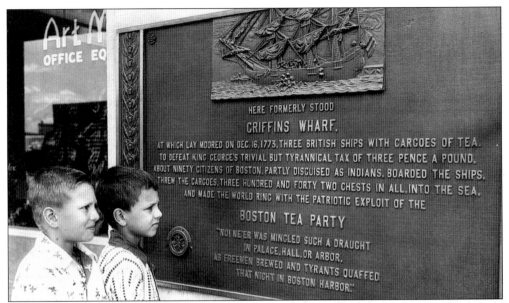

This plaque, at 470 Atlantic Avenue, marks the site of Griffins Wharf. Here, on December 16, 1773, local revolutionaries led by Samuel Adams protested British Colonial taxation. Masquerading as Mohawk Indians, they passed through a crowd of spectators, went aboard three ships, broke open tea chests, and heaved the contents into the harbor. The electrifying news of the Boston Tea Party spread, inspiring similar acts of resistance. (Boston Herald-Traveler, 8/57.)

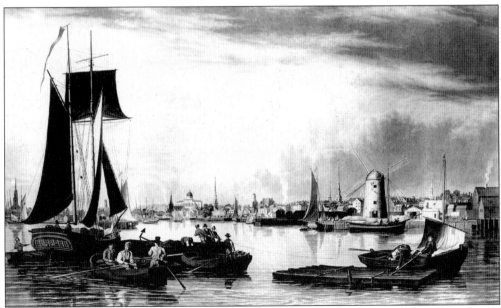

As Boston prospered, its reputation as a maritime gateway to America grew. In this c. 1820 lithograph, Windmill Point and the South Cove are seen as a bustling harbor front of wharves, ropewalks, and shipyards. This waterfront now comprises the Leather District and South Station. Today, the raft in this image would be found high and dry in Dewey Square. (Society for the Preservation of New England Antiquities.)

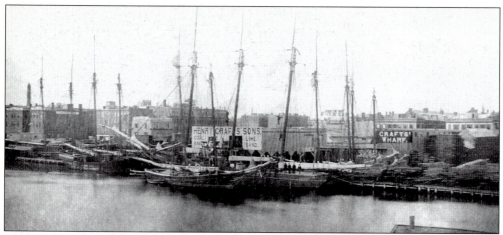

This westward view is from the old Broadway Bridge in 1877. Here, lumber schooners, usually from Maine and Nova Scotia, are tied to Crafts Wharf, near the present site of Pine Street Inn in Boston's South End. For decades, this area, bounded by the channel and Albany Street, was an important distribution point for coal, brick, granite, and lumber products. (Boston Athenaeum.)

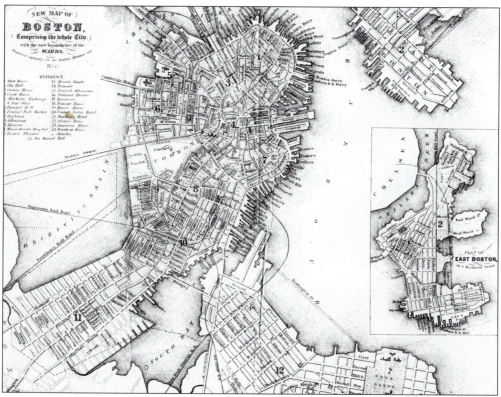

In this *Boston Almanac* map of 1856, Boston fills out as it cuts down its hills and fills its coves. Note how the wharves along the south flank of the peninsula now stretch well into the South End. The railroads cross the Back and South Bays, and a roadway (Mount Washington Street) is projected across the channel into the future Commonwealth Flats of South Boston. (Boston Public Library.)

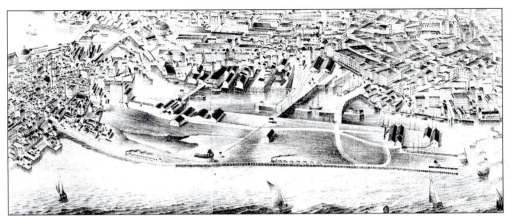

In 1836, responding to strong demand for wharf space, a group of shipowners founded the Boston Wharf Company to fill the South Boston mud flats, purchasing land along First Street and building a sea wall to enclose material from Nooks Hill, near Andrew Square. This sea wall defined the eastern boundary of the channel of today. Soon, additional "made land" attracted railroad companies to the area.

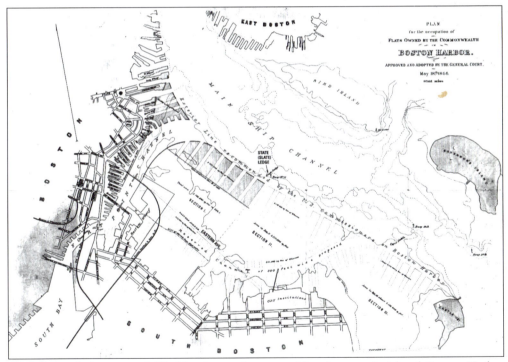

The edges of wharves and filled land were determined by the state-legislated Boston Harbor Commission. Established in 1835 to determine navigable boundaries, the commission prepared a plan in 1866 to increase port and industrial lands on Boston Harbor, Fort Point Channel, and along a "Reserve Channel." Later, a federal commission built a sea wall around the rest of the South Boston flats, defining the extent of new land decades before it was filled. (The Bostonian Society.)

This January 1930 view from the Gillette Building, in South Boston, depicts the Dover (West Fourth) Street Bridge and the South End. The old Boston Fire Department headquarters tower is visible near where Craft's Wharf had stood. To the right is the New York Streets District, so called because its streets were named for the cities served by the Boston & Albany Railroad. (Boston Public Library.)

This 1925 view shows Fort Point Channel from the Boston Fire Department tower. Practically all of the land in this image is man-made. A lone schooner is seen berthed off Albany Street. By 1958, construction of the Southeast Expressway and "slum clearance" programs had obliterated this scene. (Boston Public Library.)

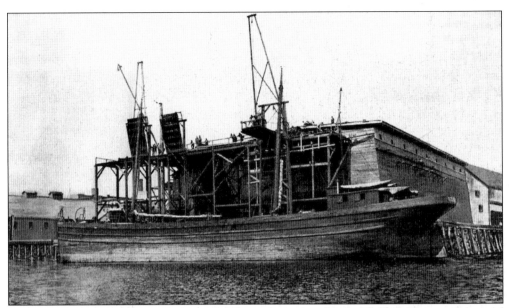

Channel-bound barges often docked off Albany Street, in the South End. Here, a converted sailing vessel is berthed along the A. J. Bradford Company coal wharf and elevator, at the foot of East Canton Street near Boston City Hospital. Note the wharf's sloped walls, designed to receive the heaps of heavy coal. The South End's brick row houses are nearby. (Boston Athenaeum.)

By the mid-20th century, the upper Fort Point Channel became an eyesore and a public health hazard. In 1960, official proposals to enclose the waterway finally gained popular support. Shown here, the old Boston City Stables, near Boston City Hospital on Albany Street, were located along what was also called the Roxbury Canal. Note the ornate lintels and gambrel roof of the Victorian-era stable. (Boston Herald, F. Kelly photograph, 11/62.)

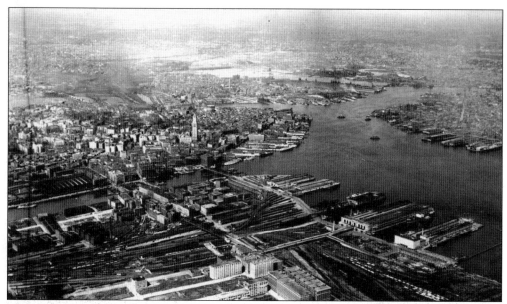

This 1925 aerial view depicts the rail activity along the lower channel and adjacent Boston Wharf Company holdings. The railroads and the Commonwealth spurred the filling of this area in the 1870s. Soon, the Boston Wharf Company sold 25 acres consisting of the Fan Pier to the Hartford & Erie (later New Haven) Railroad and 50 acres to the Boston & Albany Railroad. Rail activity thrived here until the late 1950s. (Boston Public Library.)

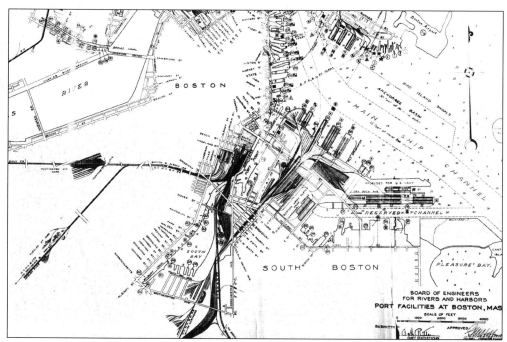

This map from the *Maritime Association of the Boston Chamber of Commerce Handbook* of 1933 shows the extent of rail yards then serving industries near the channel and the harbor. Note the Reserve Channel is now well defined. And despite a decline in navigation, new wharves appear near Southampton Street on the South Bay. (Boston Public Library.)

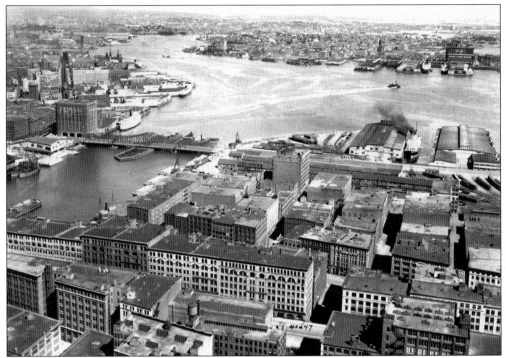

This 1925 aerial view shows the Boston Wharf Company's multiple brick-and-timber warehouses that exist today. Most were constructed at the beginning of the 19th century. Designed by the company's staff architects, Morton D. Safford and Howard B. Presscott, the buildings form an aesthetically unified precinct, now under consideration for landmark designation by the city of Boston. (Boston Public Library.)

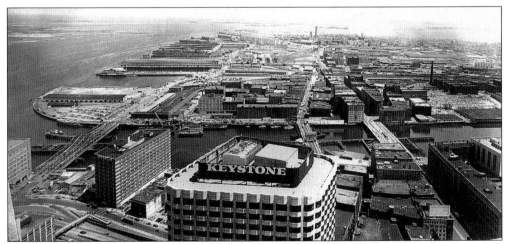

This June 1971 view from atop the new First National Bank of Boston tower in downtown Boston captures the Fort Point District just prior to its period of renewal. Commonwealth and Fan Piers can be seen to the left. Note the conversion of rail yards to parking lots. The sprawling, decayed South Station complex remains, as do properties later occupied by the Federal Reserve Bank. (Boston Herald, C. Campbell photograph.)

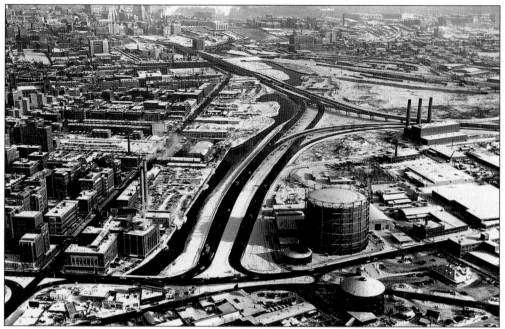

A fresh snowfall defines the remaining Fort Point Channel-Roxbury Canal waterway, now totally filled in. Dorchester Brook, a sister tributary, is visible above the Southeast Expressway. City planners hope to renew this corridor as a bicycle-and-pedestrian "Harbortrail" reconnecting Roxbury to Boston Harbor. Of the cylindrical gasholders in the foreground, only the lower brick structure remains—converted for hotel use in 2001. (Herald, 2/65.)

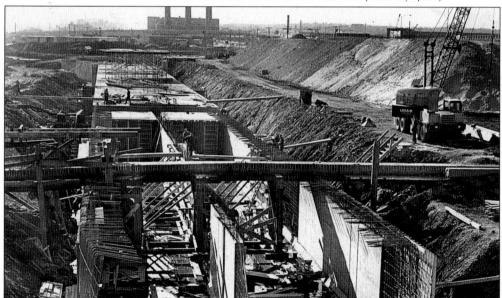

In 1954, as a sanitary measure and to create new industrial land, Massachusetts lawmakers voted to enclose the Dorchester Brook and Roxbury Canal into a giant concrete culvert. In this 1965 view, the culvert is finally under construction. In the background is the old city incinerator complex, which closed in 1974 and was demolished in 1998. (Boston Herald, O. Noonan photograph, 12/65.)

Two
Business, Industry, and Real Estate

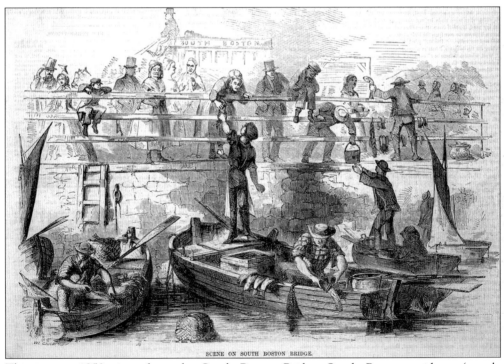

This is a c. 1850 view along the South Boston Bridge. South Boston residents (mostly mechanics and laborers) returning home from work in Boston availed themselves of the opportunity to stop at this impromptu fish market for fresh cod, haddock, and flounder. The scene upon the arrival of the boats was always lively and animated. (Boston Public Library.)

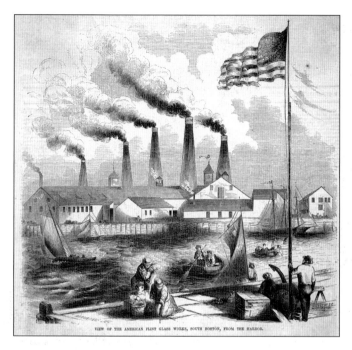

These multiple stacks belonged to the Mount Washington Glass Works, located on West Second Street near A Street. Mount Washington began operating in 1837. This view is from Boston Harbor before the South Boston flats were filled. Note the patriotic activity in the foreground. (Boston Public Library.)

MOUNT. WASHINGTON GLASS WORKS.

MANUFACTURERS OF

BLOWN, PRESSED AND CUT WARE,

In all its Forms and Varieties,

AND DEALERS IN

LANTERNS, LAMPS, BURNERS, TRIMMINGS, etc.

A LARGE ASSORTMENT CONSTANTLY ON HAND.

Orders solicited from any part of the world, and all such favors entrusted to us executed *promptly* and in the VERY BEST MANNER.

PRICE LISTS ON APPLICATION.

Mount Washington Glass founder, William L. Libbey, a pioneer of American glass manufacturing, produced a wide array of glassware including vases, pitchers, and decanters. The firm continues production today as the Pairpoint Crystal Company in Sagamore. Libbey's son Edward later founded the corporate glass giant Libbey Owens Ford Company of Toledo, Ohio. (Society for the Preservation of New England Antiquities.)

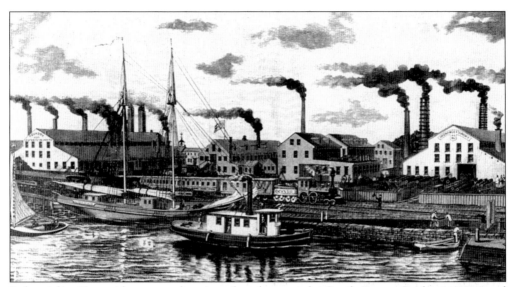

Industrialist Cyrus Alger opened an iron foundry near the South Boston Bridge in 1814 and incorporated the South Boston Iron Works in 1827. He purchased and filled the mud flats between the current Dorchester Avenue, the channel, and today's West Fourth Street Bridge to accommodate a sprawling factory complex. The sea wall in this image is visible today where it runs beneath the new Broadway Bridge.

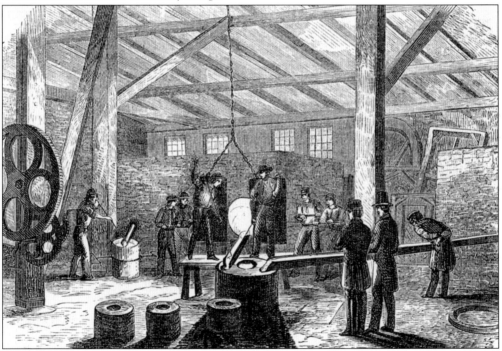

"Alger's Furnace," as it was known, manufactured cannons for the U.S. military from the mid- to late 19th century. This view depicts the crude and dangerous casting process. The cannons originally deployed at Fort Independence, on Castle Island, were made here. The site of Alger's foundry is now occupied by the maintenance yards of the Massachusetts Bay Transportation Authority (MBTA) Red Line. (Boston Athenaeum.)

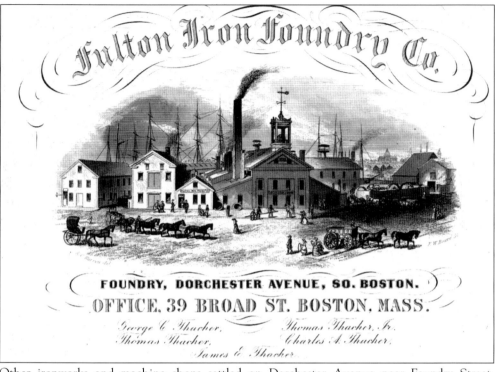

Other ironworks and machine shops settled on Dorchester Avenue near Foundry Street, including the Fulton Iron Foundry. Their advertisement, typical of industries of the day, featured ships in the background to emphasize the foundry's ability to ship goods rapidly—in this case, the channel was readily available. (Society for the Preservation of New England Antiquities.)

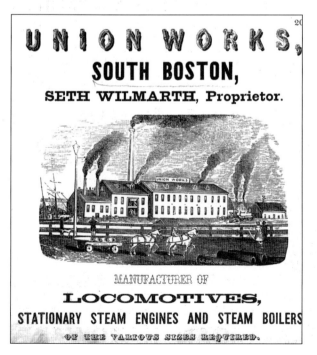

The Union Works, also off Foundry Street, was a manufacturer of steam engines for industry and transportation. By the early 1850s, owner Seth Wilmarth had added steam locomotives to his product line. In 1851, he and his engineers designed and crafted two locomotives: the *Jenny Lind* (named after a popular opera star of the time) and the *Pioneer*. (Society for the Preservation of New England Antiquities.)

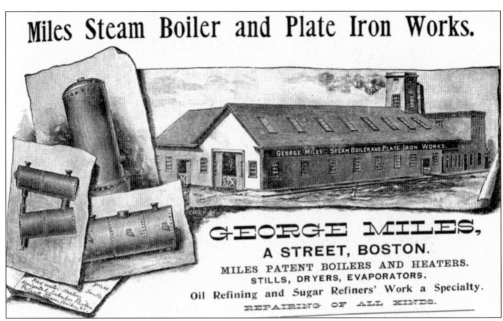

George Miles operated a steam boiler works on A Street near West Fourth Street. This advertisement proclaims Miles's specialty: building and servicing equipment for the many distilleries, sugar refineries, and kerosene works then in the area. Note the tank's hand-riveted construction in the illustration. (Boston Public Library.)

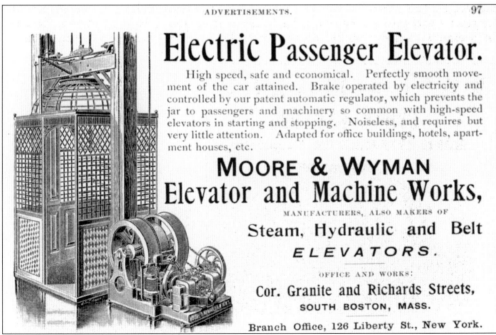

The Moore & Wyman Elevator and Machine Works was an early manufacturer of elevators, servicing Boston's growing inventory of multistory buildings. The new technology spurred local competitors, some of which remain in business in Boston today. The company was located on A Street on a site now occupied by the Gillette Company.

Prior to motor vehicles, teams of horses hauled all types of goods to and from Fort Point. In this c. 1895 view, the stable is a "dealership" where workhorses were bred, sold, and traded to teamsters or businesses with delivery fleets requiring their services. This and other stables in Boston existed for many years.

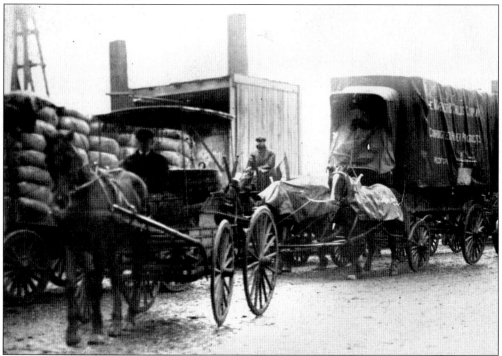

It is April 1916, and these work teams are hauling sacks of sugarcane and other goods along Northern Avenue. Teams like these were extremely common within the commercial and industrial streetscape of Fort Point. Note the weather-protection gear on the horses beyond.

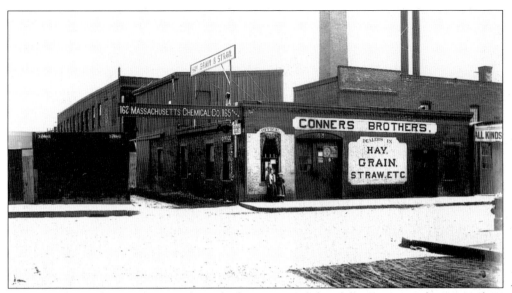

Conner's Hay and Grain business kept the horse teams fed and fit. Support industries such as these are all but forgotten aspects of Boston's economy in the late 19th and early 20th centuries. Note the adjacent chemical works—glue making, perhaps? (Boston Public Library.)

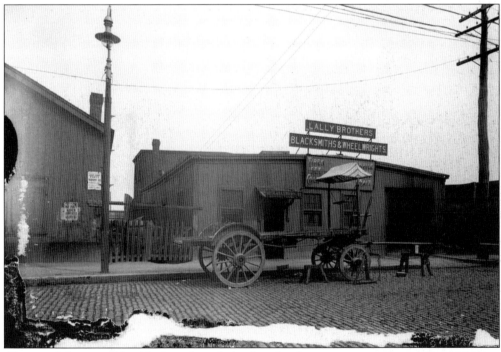

Along with horse stables, blacksmith and wheelwright shops were a common sight within Fort Point. This shop repaired and replaced wagon wheels, frames, and springs—much as body shops, gas stations, and garages do today. Note this wagon's precariously suspended driver's seat and crude canopy. (Boston Public Library.)

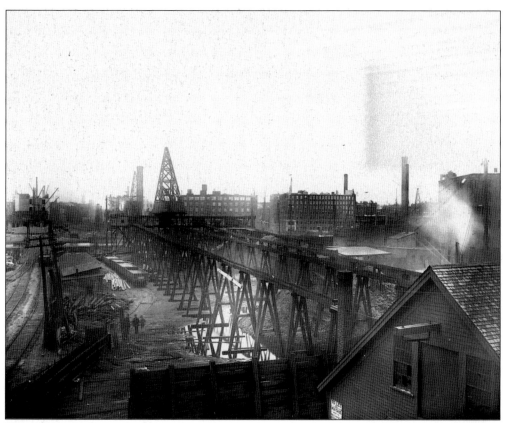

Pictured 1898, this coal gantry occupied a site along what later became Summer Street. South Station is seen under construction beyond, on the left, and the buildings in the center comprise the current site of the Federal Reserve Bank tower. The new Tufts Building is to the right and, today, is home to numerous architectural firms. (Boston Public Library.)

This typical sugar-and-molasses shed along the channel is viewed looking southward from the Mount Washington Street Bridge c. 1890. A derivation from the infamous triangle trade, most of these buildings were demolished for more extensive real-estate development, including construction of the large American (Domino) sugar refinery. (Boston Public Library.)

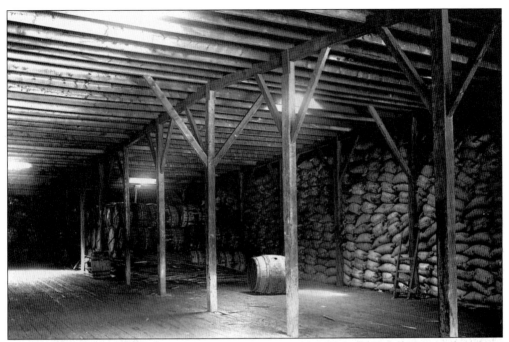

This typical shed interior shows the sacks of sugar and barrels of molasses stored for later processing. Soon, these facilities proved obsolete, as the land they occupied became valued more for other industrial and commercial uses. Then as now, Fort Point real estate underwent transformational cycles that reshaped its landscape. (Boston Public Library.)

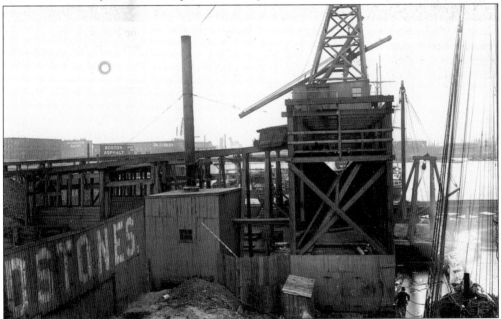

A gritty landscape—this coal crane unloads a vessel docked on the channel near today's Necco Street. The coal industry provided a critical energy source for Boston businesses, homes, and transportation until the discovery of Pennsylvania crude oil in 1861 revolutionized the energy industry. Note the advertisement for grindstones nearby. (Boston Public Library.)

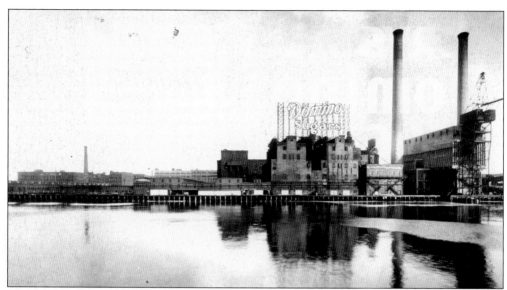

Among the many sugar processors to operate in Fort Point, the American Sugar Refining Company was the largest. This plant was built in 1902 to produce Crystal Domino sugar, a familiar brand to this day. This October 1940 view is looking eastward toward South Boston from Dorchester Avenue. (Boston Public Library.)

Adjoining the channel, the American (Domino) sugar refinery received hundreds of vessels annually to unloaded sugarcane and other produce from the Caribbean region and South America. Among the ships were those of the Great White Fleet of the United Fruit Company, of Boston origin, which directed vessels to this and other Boston docks to supply the region with bananas and other produce. (Society for the Preservation of New England Antiquities.)

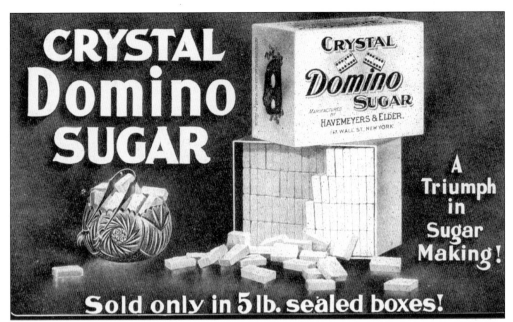

Domino sugar was manufactured in granule, cube, powder, and syrup forms. In 1958, the Domino refinery relocated operations to Charlestown, along the Mystic River. Although no longer operating in Boston today, Domino remains a common household food item.

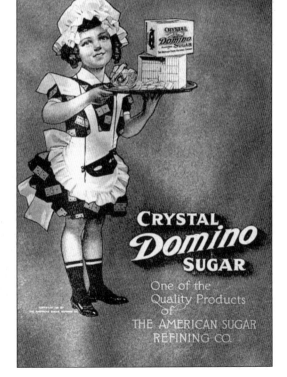

This serving girl was among Domino's trademark magazine advertisements of the early 20th century. The Domino name was derived from the sugar cubes resembling domino game pieces. Note the dominos on the server's dress and her black Venetian mask (also repeated on the package).

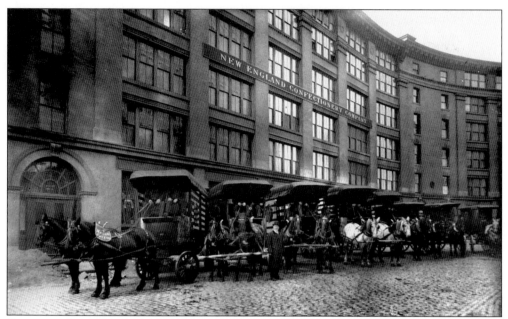

Constructed in 1902, the building at 253 Summer Street was home to the New England Candy and Confectionery Company (Necco) until it relocated in 1928. Designed by Morton Safford, the Boston Wharf Company staff architect, the building possesses an unusual curved east wall that conforms to the bend in Melcher Street, seen here. These teams are staged to display the company's delivery capacity. (Necco Corporation.)

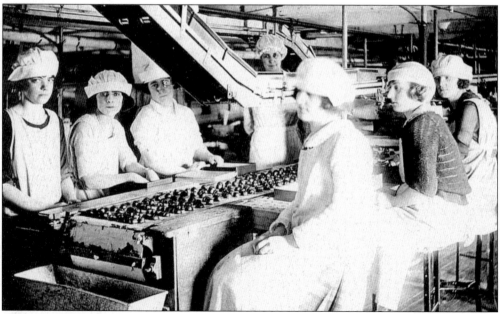

These young women are manufacturing candy for Necco c. 1912. The company still produces famous brands such as Mary Janes, Clark Bars, and Canada Mints. Its most famous product, the ubiquitous Necco wafer, was sold the world over. In 1913, the explorer Donald MacMillan took Necco wafers on his Arctic expedition for nutrition and as rewards for Eskimo children. (Necco Corporation.)

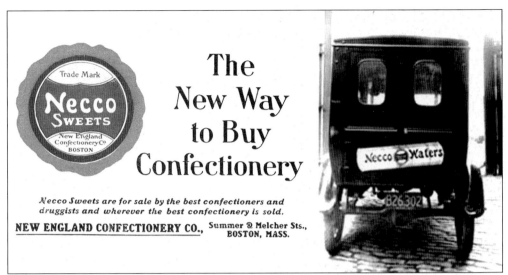

Necco took pride in its up-to-date, state-of-the-art business practices. Its motorized fleet was innovative for its time, giving the company greater convenience and reliability when shipping to retailers across Boston and nationwide. As seen here, Necco advertised its famous wafers on the back of its delivery vehicles. (Necco Corporation.)

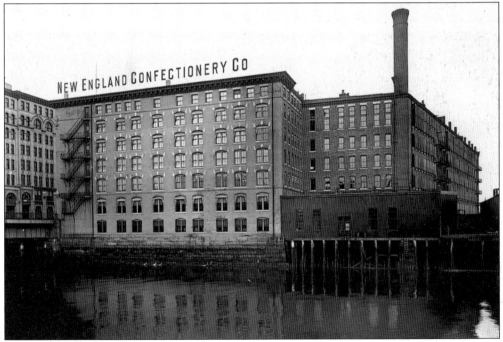

Necco was located on Fort Point Channel near its upstream neighbor, American Sugar Refining. In 1928, Necco moved its operations to Cambridge to a new and larger factory on Massachusetts Avenue, near the Massachusetts Institute of Technology campus. This well-preserved building, with its channel views and district-gateway location, now functions as an office building and current home to the Boston Wharf Company. (Boston Public Library.)

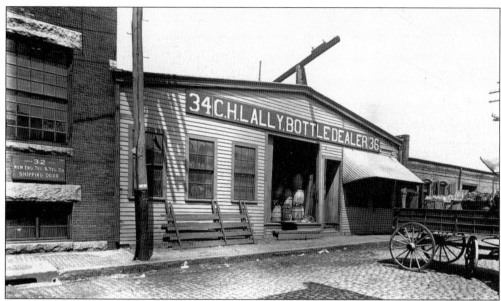

The products of C. H. Ally Bottle Dealers were in high demand by the many breweries that operated in Fort Point, as well as nearby chemical works and other industrial and commercial businesses. Bottles were recycled here early into the 20th century. Note how the wagon and the crude loading dock are loaded with barrels of bottles ready for processing and redistribution. (Boston Public Library.)

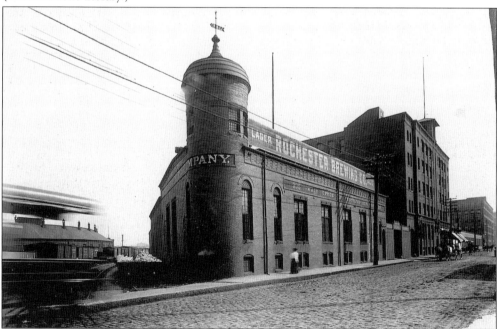

Located on A Street along the old Air Line rail approach was the Rochester Brewery, one of many breweries that operated in Fort Point to serve Boston's thirsty restaurant and tavern patrons. The Narragansett, Bay State, and Boston Beer Companies all brewed here. The former House of Bianchi building stands just beyond the brewery. Note the vintage streetcar on the left. (Boston Public Library.)

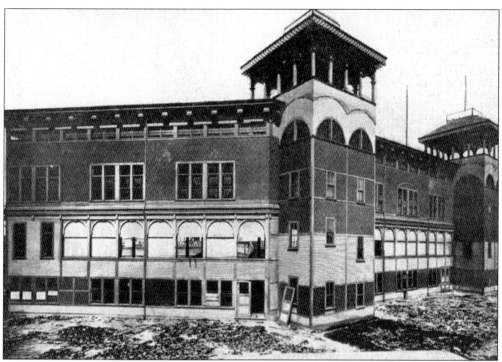

The Brotherhood Baseball Grounds was built in 1890 near today's Pittsburg Street. The wood-frame stadium had limited seating capacity, and its architectural details echoed those of the neighboring wharf buildings. Note the empty sugar sacks in the foreground. These were often laid out in the sun by nearby refiners for drying after washing. (Boston Public Library.)

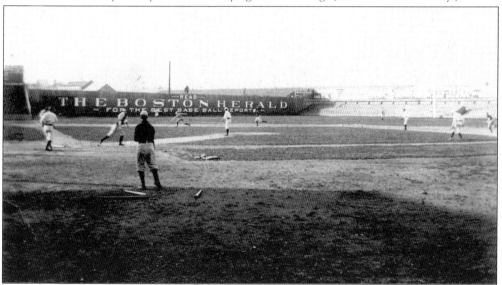

This view depicts live action on the field of the Brotherhood Baseball Grounds. Note the vintage uniforms and the newspaper billboard ringing the outfield. In this field, early baseball great Mike Kelly trained, and on May 30, 1894, Boston Nationals player Bobby Lowe became the first major-league player to hit four home runs, all in a single game against Cincinnati. (Society for the Preservation of New England Antiquities.)

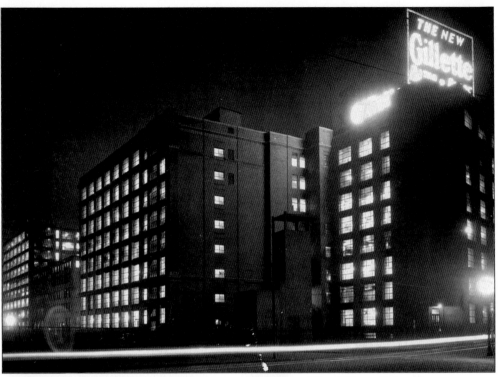

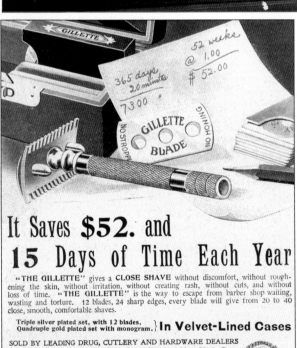

The Gillette Safety Razor Company was founded in South Boston by King Camp Gillette in 1901. Soon nationally recognized, the company covered 13 acres of interior space by the 1930s. This night view shows the plant running an evening shift at full capacity. The 1904 advertisement uses King Gillette's image to promote his products. Today, Gillette is an international company with plants located worldwide.

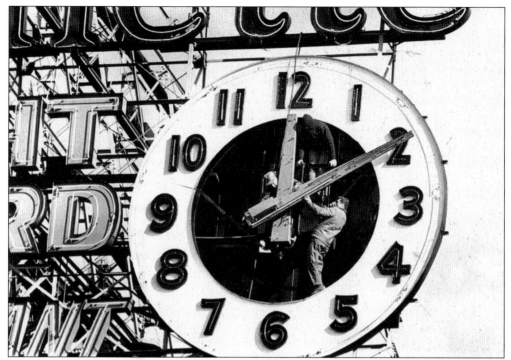

Gillette's former landmark clock is seen undergoing repairs. Visible at night for one mile, it stood atop the building at the corner of Dorchester Avenue and West Second Street until it was replaced in 1963 by the familiar "World Shaving Headquarters" sign placed atop a new factory wing facing Fort Point Channel and the Southeast Expressway. (Boston Herald, J. Landers photograph, 10/67.)

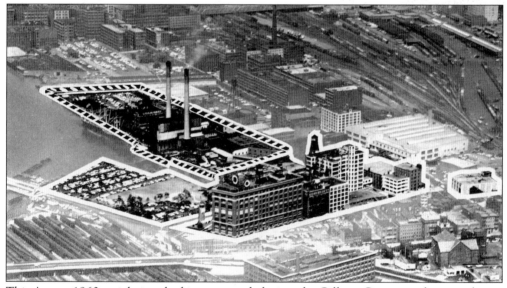

This August 1960 aerial view, looking eastward, depicts the Gillette Company plant in relation to the parcel occupied by the aging American refining plant just beyond. Gillette purchased the land in 1960 for expansion. Over the next two years, Gillette demolished the old refinery and built a vast single-story manufacturing wing. (Boston Public Library.)

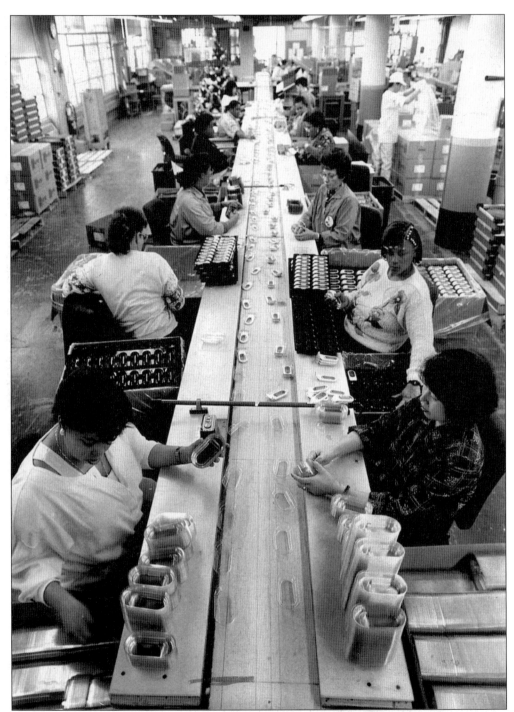
With thousands of workers, the Gillette Company is Boston's largest single employer; workers perform a variety of skills including product testing and market research. Here, employees pack shavers along a high-tech conveyor system. Gillette's South Boston plant manufactures and ships millions of blades to markets across the United States and Canada daily. (Boston Herald, M. Fein photograph, 12/92.)

This building at 263 Summer Street was constructed in 1905 to house the Boston Wharf Company. It defines the entry to Fort Point for those crossing eastbound over the channel. Designed by Morton D. Safford, the firm's staff architect from 1893 to 1917, the building's curved facade, rusticated base, and articulated cornice lend it great visual distinction. This looks northwestward, up Melcher Street. (Boston Public Library.)

On each Boston Wharf Company building is a bronze medallion approximately two feet in diameter proclaiming the year the particular Boston Wharf Company structure was erected. One of the latest is seen here, affixed to a parking garage that was built recently on Farnsworth Street. Note the classical egg-and-dart pattern emblazoned along the medallion's perimeter. (Author's photograph.)

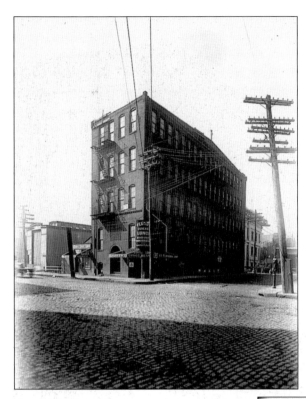

This building, at the corner of A and Congress Streets, was first occupied by the Tremont Electric Lighting Company. A pioneer in electrical manufacturing, the company turned out meters, motors, and incandescent lamps from "one to 100 candlepower." Constructed in 1887, it is among the Boston Wharf Company's earliest real-estate developments. The building was later widened to twice its capacity. (Boston Public Library.)

Many Boston Wharf Company buildings were developed with rail sidings to allow for easy freight access. The boxcars seen here typically supplied tenants with various materials for manufacturing or processing, after which they could be reloaded for shipping to national markets. The freight railroads of the period thrived on this form of access and distribution. (Boston Public Library.)

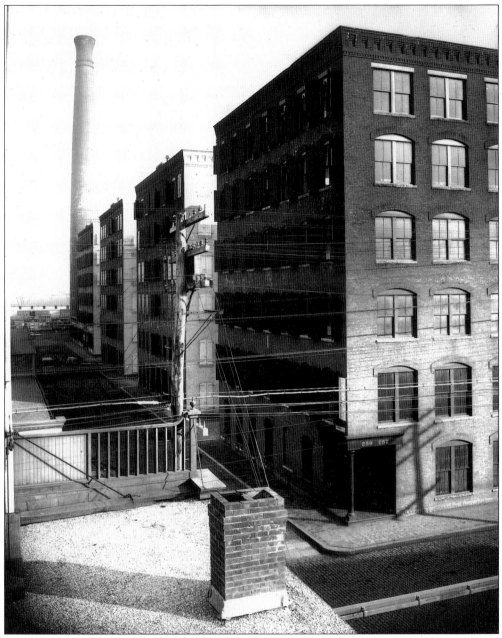

Built on speculation in 1895, the Factory Buildings Trust complex, located between Wormwood, Binford, and A Streets, was an early form of the industrial park. It housed numerous light industries including the Atlantic Machine Screw Company. Today, it contains Fort Point's oldest artist-owned housing cooperative and its landmark, the 222-foot-high smokestack, serves as a cellular antenna tower. (Boston Public Library.)

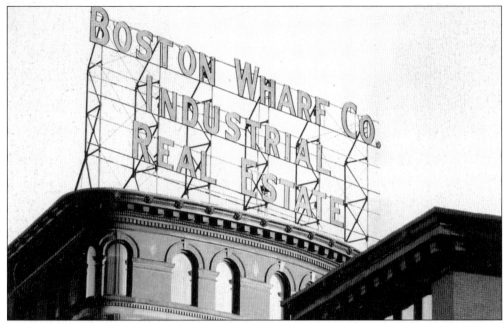

The Boston Wharf Company real-estate sign is another Fort Point landmark. It sits atop the company's already distinguished old headquarters building. Formerly wired for neon, it glowed at night to attract new business to an area in decline after World War II. Today, the sign is a unique functional relic worthy of restoration. (Author's photograph.)

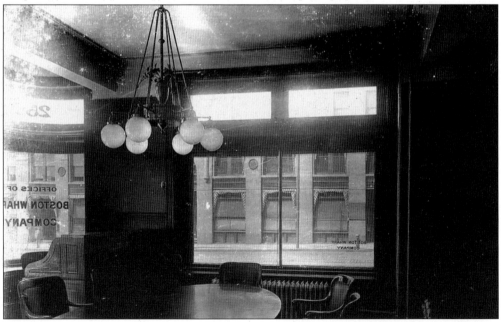

This interior view of the Boston Wharf Company's conference room in 1905 offers a semblance of the business environment at the beginning of the 20th century. Note the roll-top desk, ornate brass chandelier, and heavy wooden furniture within the room. Beyond, through the windows, can be seen the typical medallions found on each Boston Wharf Company building facade. (Boston Public Library.)

On the left in this view looking eastward down Congress Street is a structure built in 1880 by masons Gooch & Pray for the New Haven Terminal Stores. Located at 316 Congress Street, the building was occupied by the children's museum in 1979. Exactly opposite is 313 Congress Street. Built in 1887, it housed the United States Leather Company and was converted for office use in 1985. (Boston Public Library.)

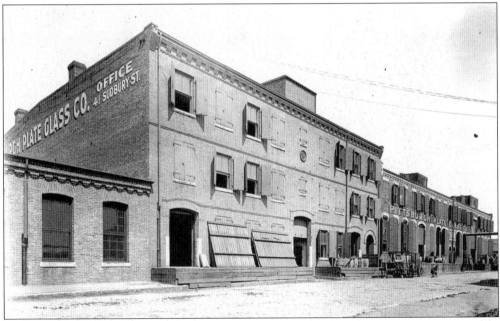

In this view looking southward down Pittsburgh Street are the warehouse and cutting facilities of the Pittsburgh Plate Glass Company. Built by "the Wharf" (Boston Wharf Company) in 1900 to house heavier industries, these lower structures benefited from close access to the rail yards nearby. Today, the Thomson Financial Corporation occupies the building and the street is called Thomson Place. (Boston Public Library.)

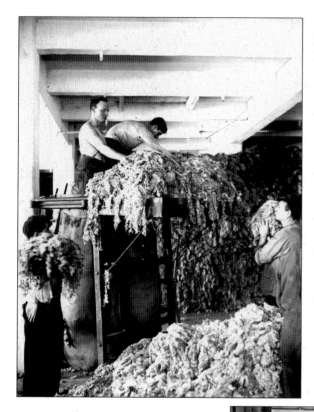

Here, in June 1909, workers pack wool into sacks for wholesale distribution. Starting in 1882, the Boston Wharf Company built numerous brick warehouses to serve the region's expanding wool trade. Many wool merchants moved across the channel from Dewey Square to occupy these new warehouses mostly situated along Summer Street. By 1930, Fort Point was the center of the wool trade in the United States. (Boston Public Library.)

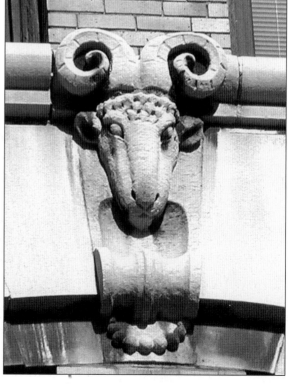

Boston's wool trade was launched by a technical advantage, developed through the telegraph, that allowed for highly accurate market forecasts. This sheep's head keystone celebrates Boston's market hegemony within the architecture of Fort Point. (Bob Souther photograph.)

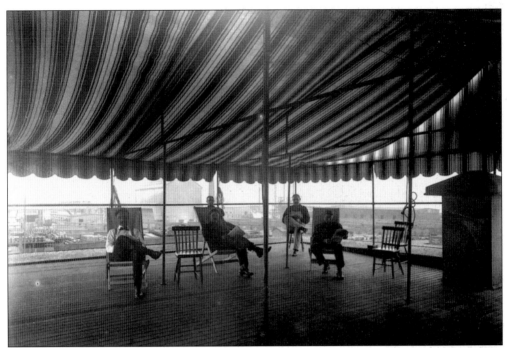

These men relax in the shade of a roof-deck canopy. They are employees of a wool distribution company housed in the building below. The perch afforded spectacular views of the harbor and cool breezes prior to air conditioning. Today, this rooftop serves the same purpose—for artists. Note the coal storage warehouse on the harbor front beyond. (Boston Public Library.)

The Boston Wharf Company properties are notable as groupings of warehouses that typify the Renaissance Revival style. Among these is 300 Summer Street. Built in 1898, it housed the Francis Willey Company, a wool importer and dealer. This 1900 view is looking northward across the A Street overpass. Today, the building houses a large artist's cooperative, gallery, and cafe. (Boston Public Library.)

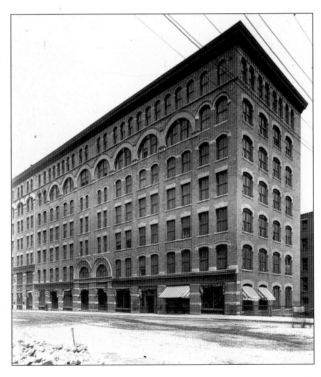

Boston was heralded for its expertise in the wool industry in these advertisements from the 1963 World Wool Guide. However, after almost a century-long presence in Fort Point, foreign competition and synthetic textiles ended the industry's significance here. By the late 1970s, many of the wool "palaces" were adapted as artists' work spaces.

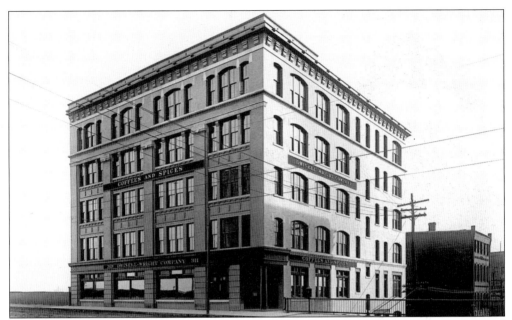

This 1904 view depicts the Dwinell-Wright Company at 311 Summer Street, a national distributor of coffees and spices. Dwinell-Wright's packages proclaimed "Boston Roasted Coffees stored and packed in the lightest and most sanitary factory in the world." Built by the Boston Wharf Company, the building also housed Fort Point's last wool merchant, Forté Dupee Sawyer Company, from 1921 until it relocated to Natick in 2000. (Boston Public Library.)

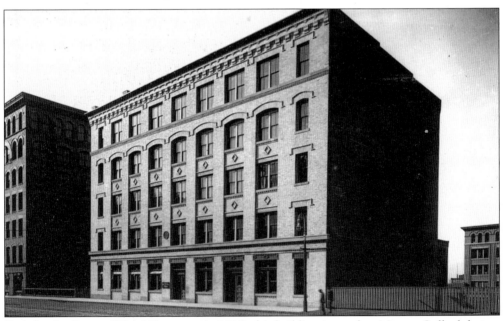

Built by the Boston Wharf Company in 1910, this building is another Morton Safford design. Here, Safford used brick mainly to express detail, creating a restrained effect. The building housed a variety of commercial uses including a wholesale dry goods operation and a drapery fabric supplier. The building currently houses artist workspaces. (Boston Public Library.)

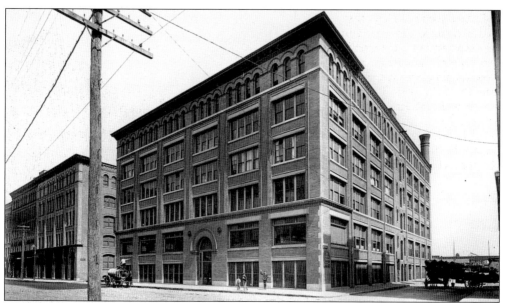

Built in 1901, 368 Congress Street is an elaborate yet modern design by Boston Wharf Company architect Morton Safford. Constructed of Pompeian brick and trimmed with sandstone quoins and sills, it has broad, sharply regimented fenestration suggesting the influence of the Chicago style of architecture. The building was occupied by the W. H. McElwain Company, who were shoemakers. (Boston Public Library.)

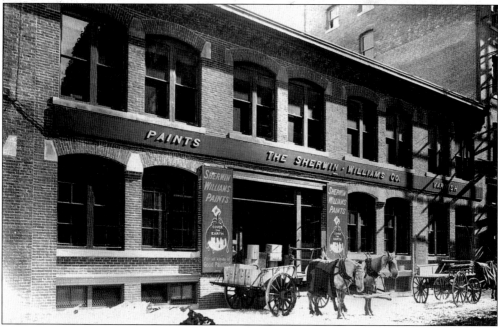

This two-story building on Farnsworth Street was demolished for a parking garage in 1998. It was among the rare low-rise wharf designs built by the Boston Wharf Company. Here can be seen the Boston distributor of the Sherwin-Williams Paint Company. Its "Cover the Earth" logo, familiar even a century ago, is apparent in this photograph, where a horse team is seen preparing for a delivery. (Boston Public Library.)

Built by the city in 1890, this engine house features two entry bays separated by stout granite piers that support a granite entablature. Note the fireplace chimney rising from the main gable. The building has been altered little from its original design. Unusual to Fort Point's urban fabric, it currently houses the Boston Fire Museum. (Boston Public Library.)

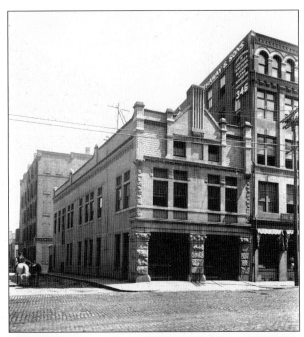

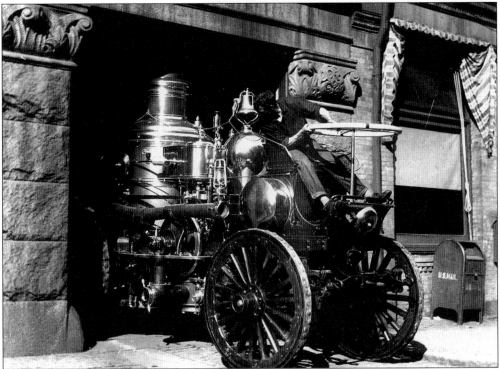

In 1919, a fireman steers a steam-powered engine into its garage at the Congress Street firehouse. Note the size of the steering wheel and the studded wooden wheels. These engines provided tremendous street theater when dispatched, creating as much smoke as the fire they were sent to put out. Note the carved granite capitals atop the station's pilasters. (Boston Public Library.)

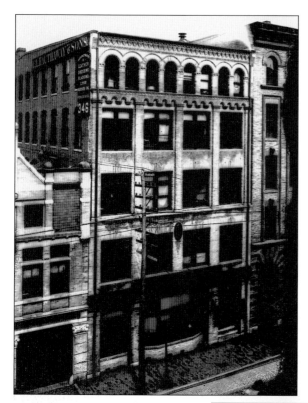

Despite its proximity to the Congress Street engine house, this fine building was completely lost to fire. Another of architect Morton Safford's Renaissance palazzo-inspired designs, the building featured Pompeian brick and terra-cotta details, as well as fanciful brick corbels. It housed a leather tannery and wholesaler. (Boston Public Library.)

In 1952, this building on Sleeper Street is completely engulfed by smoke as firefighters respond and onlookers gather. A rare occurrence today, fire did claim a small number of Boston Wharf Company buildings in the 20th century. The sites of those that burned exist as odd parking lots within the district's urban fabric. (Sleeper Street derived its name from a mattress manufacturer that once operated here.) (Boston Public Library.)

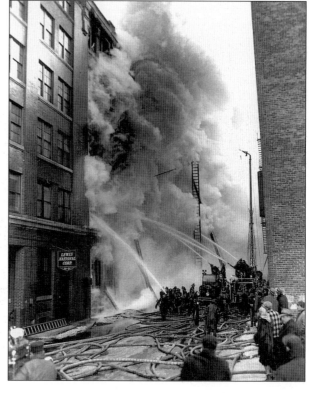

Three
BRIDGING THE CHANNEL

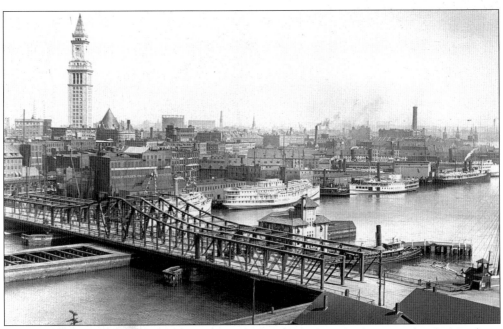

This 1919 view is from the South Boston side of the channel. In the foreground is the Northern Avenue Bridge, designed by city engineer William Pratt Jackson. Built in 1908, it has a 283-foot swing span that rotates horizontally on a rim-bearing drum. Note the Boston Fire Department's Marine Unit with its large fireboat docked alongside the bridge's fender system. (Boston Public Library.)

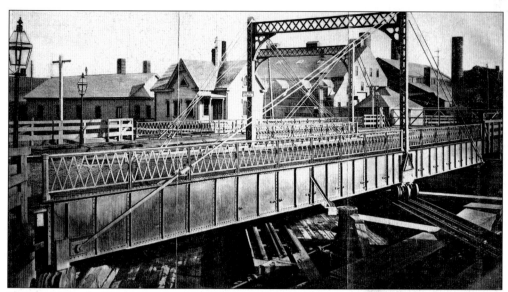

Built in 1877, the Dover Street retractile drawbridge replaced the earlier South Boston Bridge. Note the operator's house and capstan stables in the background. Using actual horsepower, a steel crankshaft was turned to open the bridge for ship navigation. The South Boston Iron Works is visible beyond. (Boston City Archives.)

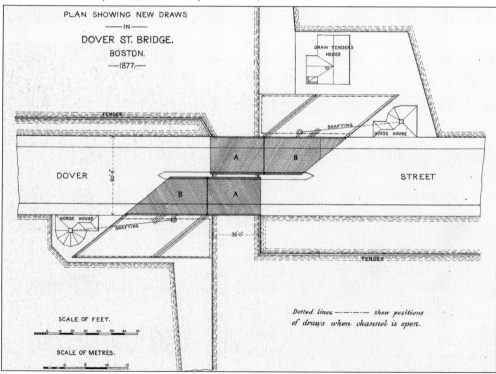

This drawing of Dover Street Bridge illustrates the unique plane geometry of the retractile draw spans. Set on angled rails, the span's leaves could be pulled away from the navigation channel. Similar bridges were built over the channel at Summer Street and Dorchester Avenue. Note again the horse-powered elements of the design. (Boston City Archives.)

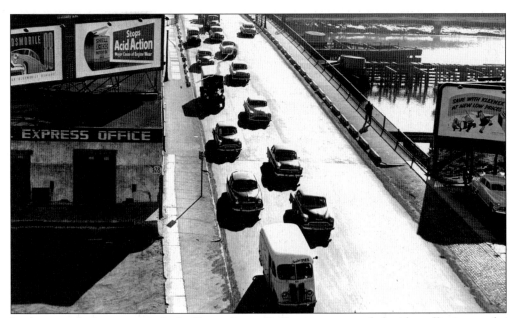

In this view looking eastward, the Dover Street Bridge is seen crowded with traffic. It was the only westward crossing from South Boston until the construction of the Broadway Bridge in 1871. By 1953, automobile use in South Boston had soared, causing traffic congestion at key access points into Boston proper and onto the Southwest Expressway nearby. (Boston Public Library.)

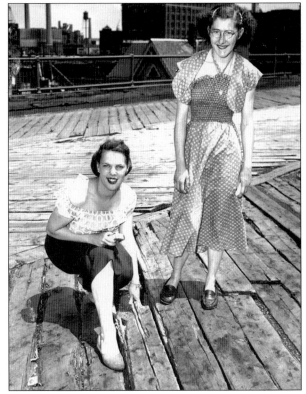

In June 1950, South Boston residents Carmelita Carpenter and Helen Ostiguy protest the condition of the Dover Street Bridge on behalf of the many pedestrians who used it daily by foot. Timber planking in many Boston bridges also presented severe fire hazards. Note how the bridge is elevated to accommodate rail traffic below (compare with top of page 50). (Boston Public Library.)

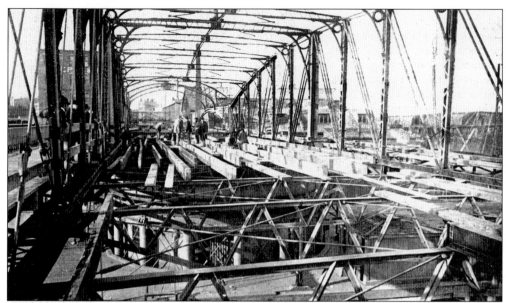

This 1877 view looking westward shows the Broadway Bridge under construction over the Fort Point Channel. Workers are installing a new timber deck over which granite pavers will be laid. This swing truss bridge is a replacement of an 1871 bridge that failed due to structural defects. Note the ornamental brackets and approach archways beyond. (Boston City Archives.)

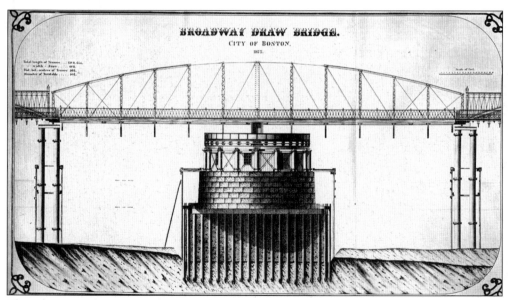

This elevation drawing of the second Broadway Bridge offers insight into the engineering technology of late-19th-century Boston. The iron rim-bearing wheel assembly over a granite drum allowed the bridge's bowstring truss to pivot open for vessels entering the South Bay. The drum was reused when the bridge was rebuilt in 1914. (Boston City Archives.)

The third Broadway Bridge was a center-bearing swing span built by the Boston Bridge Works in 1914. Unlike its old rim-bearing predecessor, the new design placed most of the bridge's weight on a central point in the middle of the drum. The bridge had fewer moving parts and opened faster than its predecessors. (Historic American Buildings Survey-Historic American Engineering Record.)

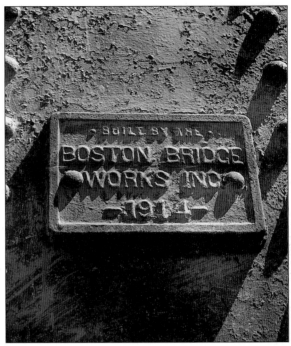

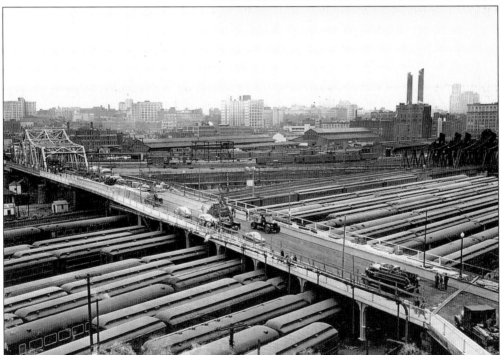

Looking westward from the roof of the Court Square Press Building, in South Boston, this view shows the South Boston approach to the Broadway Bridge undergoing repairs. The bridge was designed to accommodate carriage traffic and trolleys over the New Haven's Cabot Rail Yard, now occupied by the MBTA's Red Line car storage and maintenance facility. (Boston Public Library.)

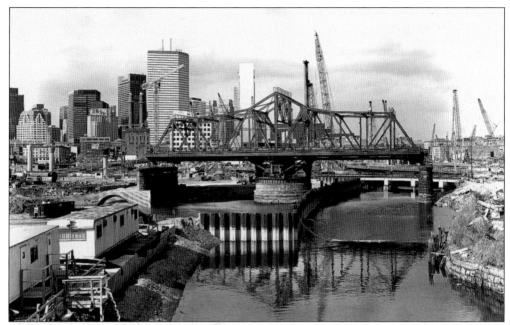

The third Broadway Bridge is prepared for demolition to make way for the Central Artery's new southern approach ramps and Interstate 93 tunnel connection into South Boston. (Note the absence of the bridge approaches.) In 1999, the span was opened one last time to aid the welder's torch. This view is from nearly the same location as the image below. (Don Eyles photograph.)

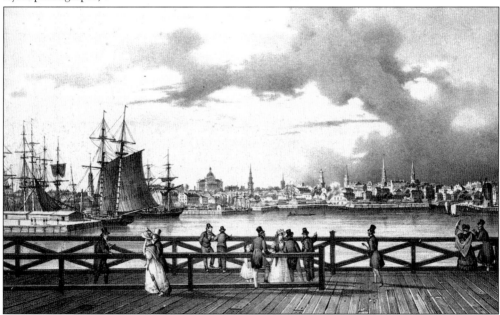

This lithographic view depicts the South Boston Bridge c. 1820. Built in 1805, the South Boston Bridge was the first bridge to access South Boston. Popular as a strolling promenade, the bridge attracted well-attired Bostonians who would gather here after church services to absorb the panorama of Boston across the channel. Note the new Massachusetts State House dominating Beacon Hill beyond. (Boston Public Library.)

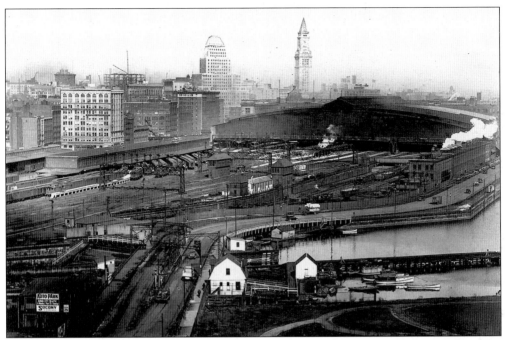

Looking northward from Gillette in 1928, the Dorchester Avenue Bridge appears cluttered by boating activity. Built as the North Free Bridge in 1826, it was South Boston's second link to downtown Boston. The bridge's skewed roadway resulted when Federal Street, taken in 1897 for the South Station yards, was rerouted around the terminal and renamed Dorchester Avenue. (Boston Public Library.)

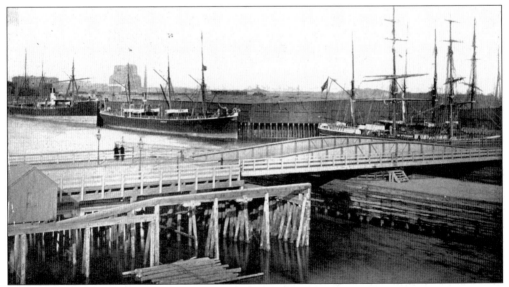

This view is looking eastward from Dorchester Avenue, with the Mount Washington Street Bridge in the foreground. Opened in 1855, the bridge linked Kneeland Street to the new Commonwealth Flats and Boston Wharf Company land. Note the steam freighters used to transport sugarcane, molasses, and other products to and from the channel's many storage sheds beyond. (Boston Athenaeum.)

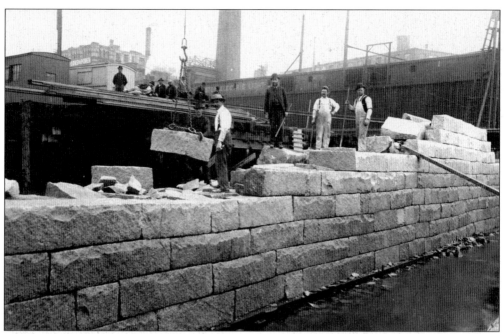

These men, likely Irish or Italian laborers, belong to a construction crew laying granite blocks for a new sea wall beside what became Dorchester Avenue, along the channel. This work was carried out in 1898 in preparation for the Boston South Terminal project. Prior to this time, as many as 10 wharves jutted into the channel at this location. (Boston City Archives.)

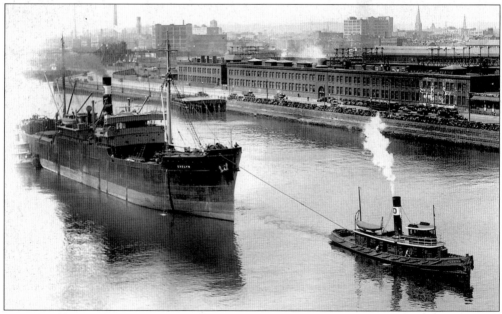

Under tow, the steamship *Evelyn* is seen in May 1929 riding high on the channel after unloading cargo at the nearby Domino plant. Such ships were often loaded with bananas for processing into sugar products at the refinery. Note the absence of the Mount Washington Street Bridge by this time. A mere stub of its deck is all that remains visible. (Boston Public Library.)

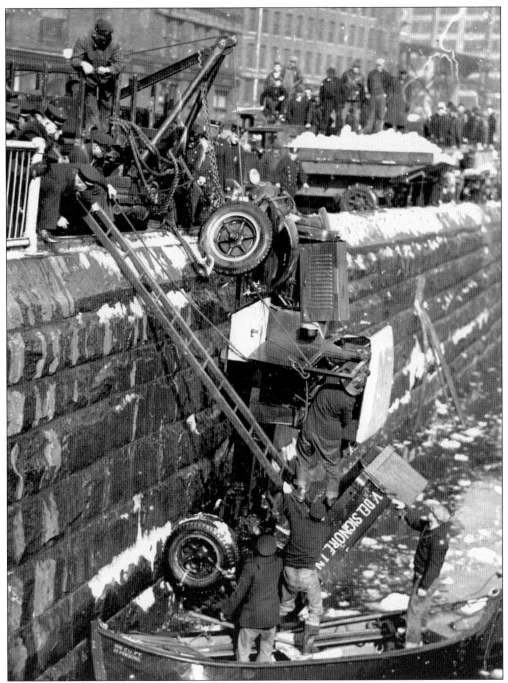

This dump truck took a plunge off the Dorchester Avenue sea wall in 1925, when it slid past the curb and tipped over while dumping snow into the channel. Note the crowd standing atop other trucks nearby. Now prohibited by law, dumping into the channel was once a common way to dispose of snow after major winter storms. (Boston Public Library.)

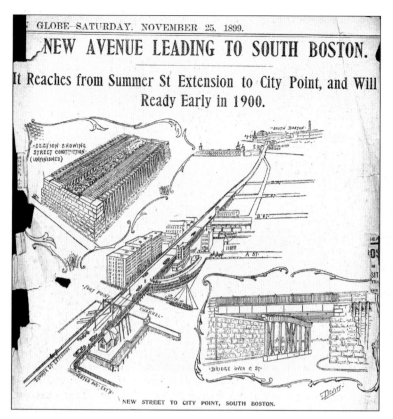

This 1898 news article announces the extension of Summer Street across Fort Point Channel and into South Boston to City Point. The elevated roadway included a new bridge and allowed for separation of traffic flows over the rail yards and A, B, and C Streets—an urban innovation at the time. Melcher Street, without its buildings, is shown. (Boston City Archives.)

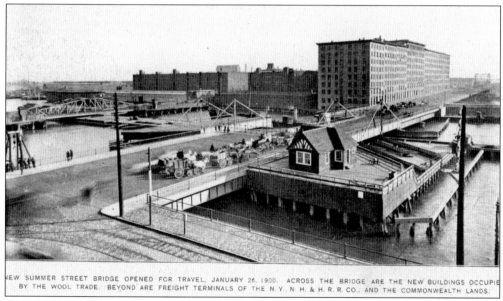

Wagon teams head into South Boston over the new Summer Street retractile drawbridge. Note the Tudor-style operator's house and new Boston Wharf Company warehouses beyond. This bridge was built in 1899 with two sections designed to pull away diagonally to permit access through the channel. (Boston City Archives.)

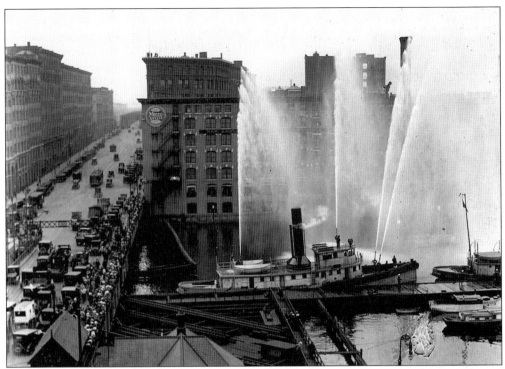

In this view looking eastward from the roof of South Station in July 1932, a crowd observes a Boston fireboat crew testing equipment along the Summer Street Bridge. These exercises helped keep the equipment in good functioning order. Note the traffic jam caused by the spectacle. The old Summer Street viaduct is visible in the distance. (Boston Public Library.)

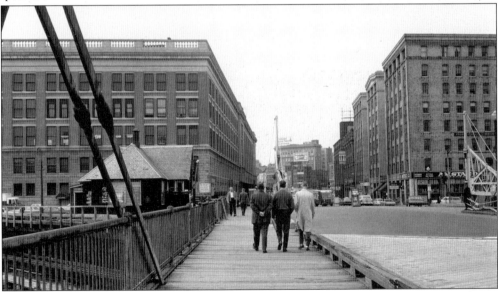

In this view looking westward toward Dewey Square, the eastern wing of South Station is seen enlarged with the addition of three stories of office space. In the foreground are the wood plank sidewalks of the Summer Street Bridge. Note the gates used to halt traffic for bridge openings. (Boston City Archives.)

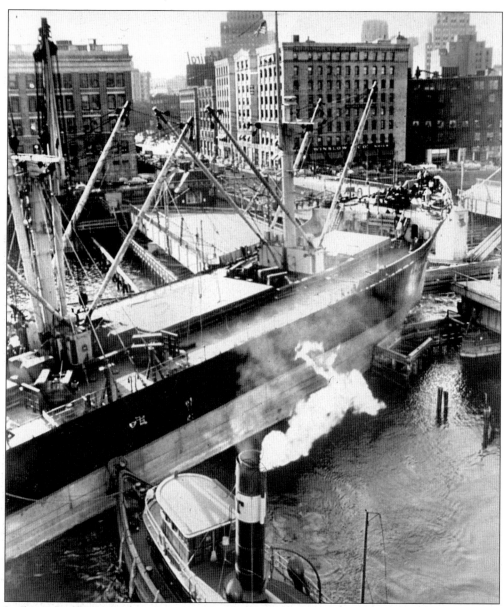

In this June 1953 view, a Cuban sugar freighter is pinned by the wind as its tug escort struggles to correct its course. Note the crowds are prevented from crossing into Boston and Dewey Square beyond. A lone crewman, perhaps calling instructions between the tug captain and the ship pilot, is seen on deck to the left. (Boston Public Library.)

This four-wheel gliding truck was one of many that supported the Summer Street Bridge as it retracted to the open or closed position across the channel. Occasionally, these trucks would malfunction, causing traffic delays above. (Boston City Archives.)

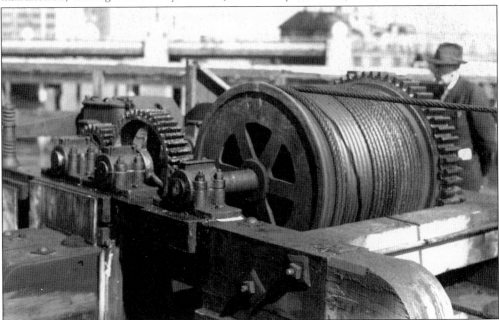

This electric-powered cable winch pulled the retractile decks of the Summer Street Bridge into their open and closed positions. This device lingered among deteriorating pilings for years until the bridge was completely renovated in 1994.

By the early 1950s, deferred maintenance of the Summer Street Bridge had begun to take its toll. In 1958, American Sugar ceased operations here and moved to a new plant on the Mystic River in Charlestown, rendering the Summer Street drawbridge obsolete. This operator's house was demolished shortly thereafter. (Boston City Archives.)

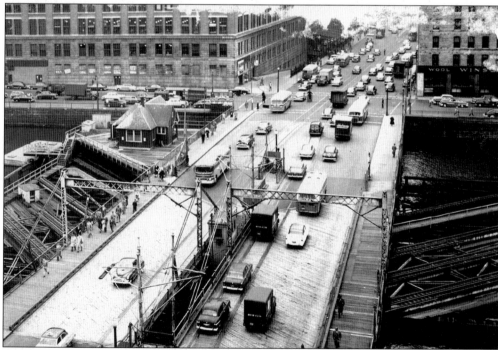

This October 1953 view of the Summer Street Bridge is looking eastward toward Dewey Square from the roof of a nearby Boston Wharf Company building. Note the busy intersection at Dorchester Avenue—then a public street—and the trolley tracks crossing the bridge. By the late 1940s, buses had replaced trolleys as the means of public access into South Boston. (Boston Public Library.)

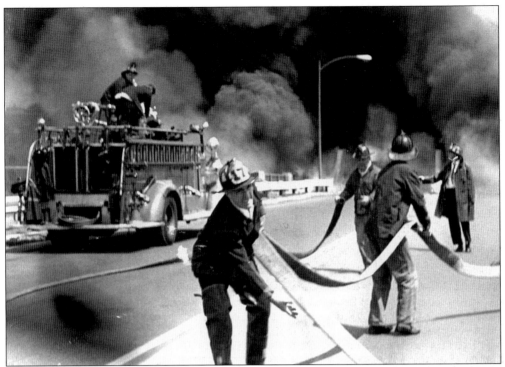

Wood was used in the construction of the decks of many Boston bridges. Often these decks would catch fire through the careless disposal of cigarette butts. Here, firefighters are dispatched in July 1965 to control a raging fire on the Dover Street Bridge. The Summer Street Viaduct later suffered a similar fate. (Boston Public Library.)

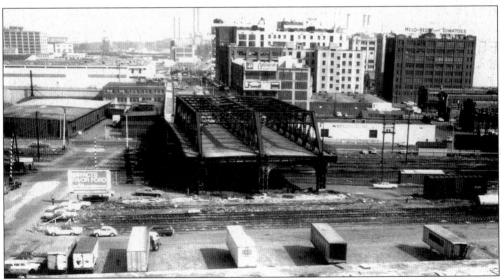

In 1970, a deck fire destroyed most of the old Summer Street Viaduct. Designed as a lattice "tunnel" spanning the rail yards below, the viaduct collapsed when the ensuing heat caused the steel to fail. The Penn Central Railroad allowed the city to rebuild the viaduct as an earthen berm structure. One truss survived until it was removed in the late 1990s. (Boston Public Library.)

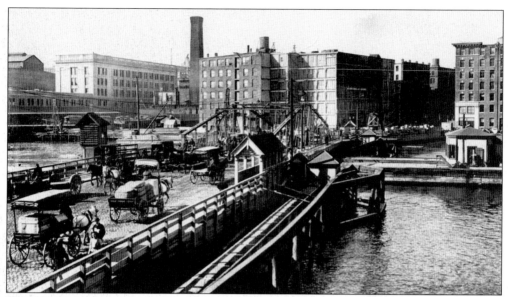

This 1902 view shows the old Congress Street Drawbridge packed with traffic. Built in 1874 to connect Boston with the northernmost Commonwealth Flats and Boston Wharf Company properties, the bridge featured odd appurtenances and pedestrian shelters. The block beyond is now the site of the Federal Reserve Bank tower. (Boston City Archives.)

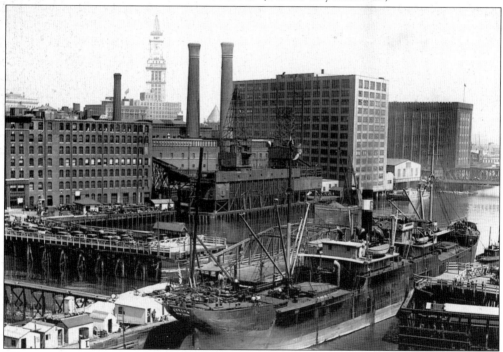

The steamship *Evelyn* leaves the channel through the old Congress Street Bridge in May 1929. Beyond on the left are the Tufts Building and the old coal-fired Atlantic Avenue Power Station. The power plant had two mammoth cranes used to extract fuel from barges. Just beyond the plant are 470 Atlantic Avenue and the crenulated U.S. Customs Stores building. (Boston Public Library.)

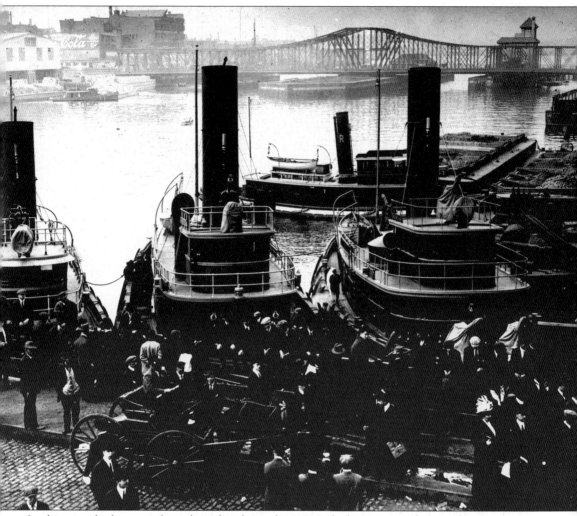

In this view looking northward on the channel c. 1910, fireboats are tied along the Congress Street Bridge for an event, perhaps a firemen's outing. The boats were vital to the safety and security of the harbor when most of the construction was wood. Note the steam whistles on the vessel's stacks and the "new" Northern Avenue Bridge beyond. (The Bostonian Society.)

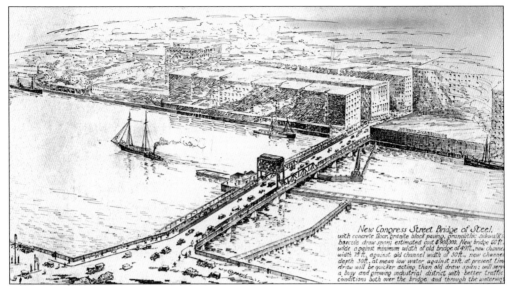

In November 1929, Mayor James Michael Curley announced his new Congress Street "Bridge of Steel" scheme. Estimated to cost $9 million, the project was a last gasp of investment along an obsolete waterway. The eyesore running parallel to the bridge is a water main. It was removed when the bridge was rehabilitated in the summer of 2004. (Boston Public Library.)

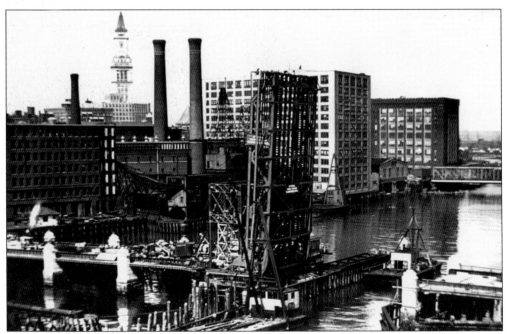

The new Congress Street Bridge is seen under construction in 1930, its draw span assembled upright. A patented trunnion bascule, it was designed by engineer Joseph Strauss of Golden Gate Bridge fame. Mayor James Michael Curley's knack for creating jobs is evident in the decorative granite piers, designed to hold large illuminating globes, a feature not seen on any channel bridge previously or since. (Boston Public Library.)

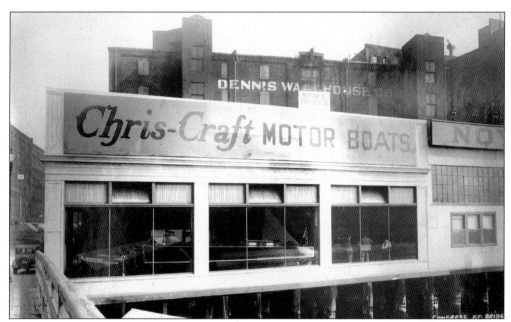

This view looks eastward from the old Congress Street Bridge toward a Chris-Craft boat dealership. Inside the showroom, a new mahogany runabout is on display. Prior to the Great Depression, this dealership was just a short walk away for the many bank presidents, stockbrokers, and businessmen who worked downtown. (Society for the Preservation of New England Antiquities.)

This photograph was taken looking northward from the South Boston side of the Summer Street Bridge toward the Congress Street Bridge on January 20, 1942. In it, a sailboat appears to have been converted into a houseboat on a part of the channel considered a safe harbor for boaters. Efforts are under way to increase boating activity in the channel today. (Boston Public Library.)

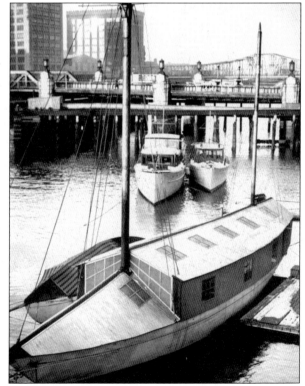

67

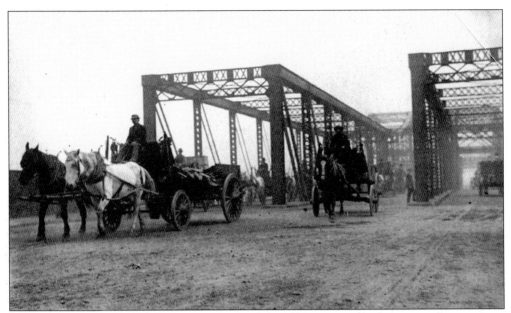

This view is looking eastward from the Boston side of the channel to the Northern Avenue Bridge. Built in 1908, the bridge was designed with a triple-barrel through truss by city engineer William Pratt Jackson. Note the dirt approaches and the horses and drivers hauling goods out of South Boston. (Boston Public Library.)

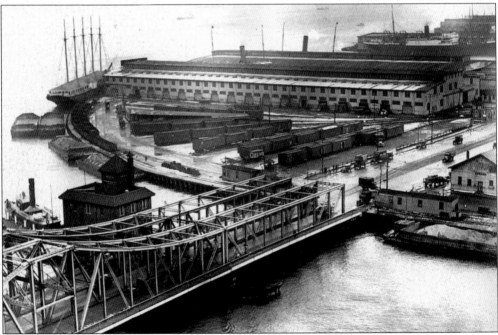

This 1929 view shows the Northern Avenue Bridge and the warehouses lining Fan Pier. The pier was named for its radial car sidings and arched sea wall, visible just beyond the bridge. Note the huge five-masted schooner berthed nearby. The single-track Union Freight Railroad crossed the bridge to link the New Haven Railroad's terminals to those of the Boston & Maine in Charlestown. (Boston Public Library.)

This c. 1916 view is looking westward from the South Boston side of the channel near Fan Pier. Beyond the bridge's structure is the Boston Fire Department's Marine Unit headquarters, installed in 1910. Farther out is the U.S. customhouse tower, built in 1915. (Boston Public Library.)

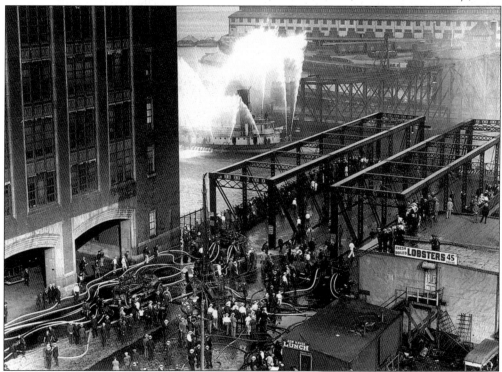

The Boston Fire Department's Marine Unit, posted at the Northern Avenue Bridge, was an exciting place to witness periodic maintenance drills. Here, in 1930, a fireboat's spray attracts throngs of people, for both the beauty and the chaotic atmosphere it generated. Note the men in straw hats and the price of lobster. (Boston Public Library.)

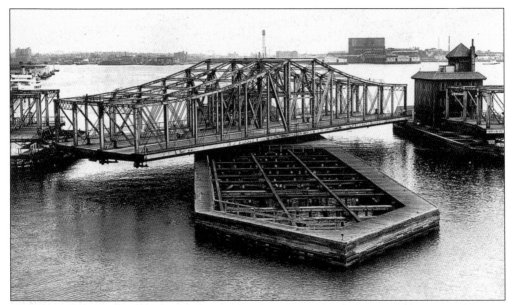

The Northern Avenue Bridge, the last working drawbridge on the channel, closed to vehicles in 1997. In this c. 1955 view, the bridge is opening for an oncoming vessel. In 2003, Boston's preservation community and city officials launched new efforts to rehabilitate the bridge as a working monument to Boston's industrial past. The success of the project may depend on the combination of public and private investment. (Boston Public Library.)

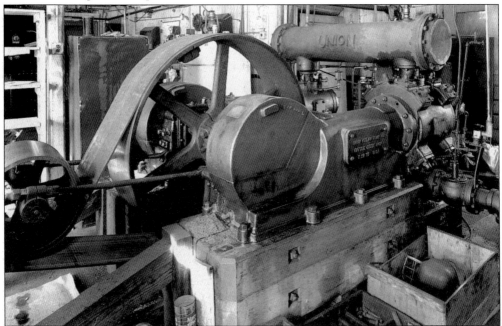

Originally operated by steam power, the Northern Avenue Bridge's opening mechanism was converted to compressed air. This electric pneumatic pump powered the gears that turned the bridge's swing span open and closed. In 1996, the bridge was replaced by the Evelyn Moakley Bridge, 50 yards to the south. Today, the bridge still opens but infrequently. (Historic American Buildings Survey-Historic American Engineering Record.)

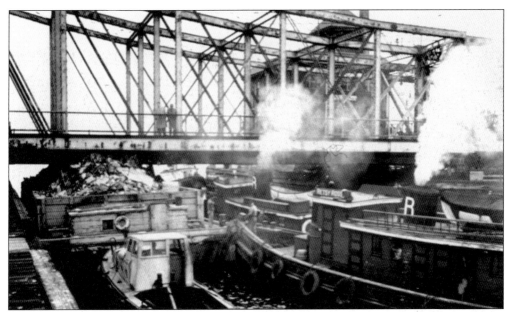

In this March 1953 scene, a malfunctioning Northern Avenue Bridge snares a trash barge beneath it. Normally, the low-stacked tugs could pass easily during high tides—but in this instance, the trash is piled too high. The city shuttled refuse from Fort Hill Wharf to Spectacle Island for burial. The wharf site is now occupied by the Moakley Bridge. (Boston Public Library.)

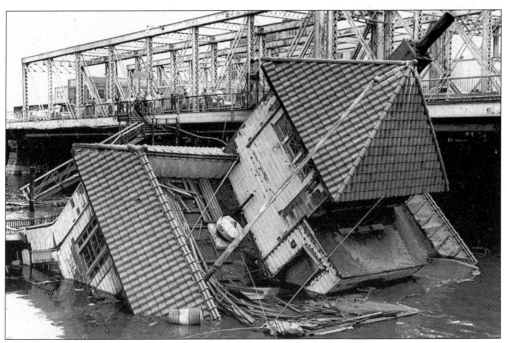

In June 1968, the Old Northern Avenue Bridge lost an old friend. Its wood pilings rotted, the old headquarters station of the Boston Fire Department's Marine Unit collapses into Fort Point Channel, creating a major cleanup challenge for the city after obstructing navigation for weeks. No injuries were reported. (Boston Public Library.)

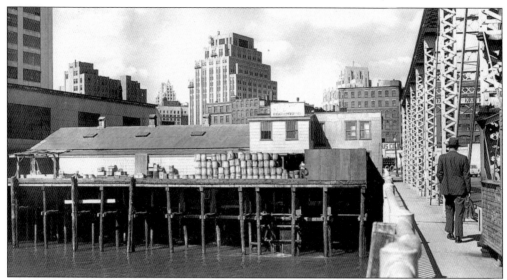

In this 1955 view looking westward, a businessman crosses the Northern Avenue Bridge en route to downtown Boston. To his left is the Hook Lobster Company Wharf, facing the channel. The Hook family has run its business from the wharf since 1925, when founder James Hook began trucking his lobster catch from Maine and Canada down to the Boston Fish Pier. (Hook Brothers.)

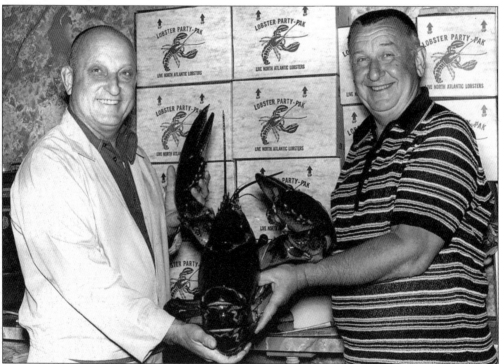

James Hook's sons, including Al (left), James Jr. (right), and Edward, expanded the business by providing direct service to restaurants and distributors across New England. Today, the company ships more than 50,000 pounds of lobster nationwide each day and is managed by four siblings of the third generation of the Hook family. (Hook brothers.)

Four
South Station and Dewey Square

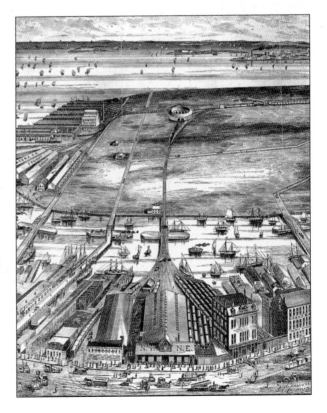

This bird's-eye illustration promotes the new South Boston, or Commonwealth, Flats for industrial and real estate speculation. In the background are the old New York and New England engine roundhouse and the sweeping curve of what was the Air Line Railway trestle. In the foreground are the Fort Point Channel and the old station head houses, now occupied by the Federal Reserve Bank tower and Summer Street.

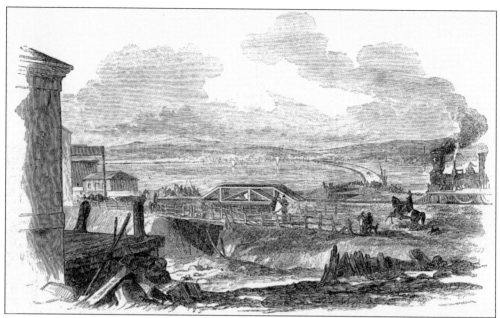

The Air Line Railway passed over the South Bay under present-day Broadway and over the South Boston Flats into downtown. This corridor was widened for expanded freight operations. Today, it contains the South Boston Haul Road, an early component of the Central Artery-Third Harbor Tunnel project. This view is looking southward toward Dorchester. Note the vastness of the South Bay marshes beyond. (Boston Public Library.)

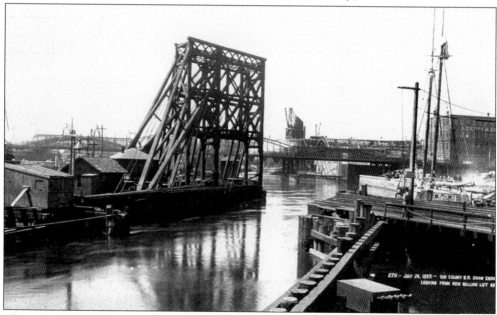

This view is looking westward up the Fort Point Channel toward the old Broadway Bridge leading into the South Bay. The strange timber framework to in the foreground is the first Old Colony Railroad Bridge. This crude structure was a jackknife drawbridge. It functioned by hinging its cantilevered rails individually to meet the rails on the opposite shore. (Author's collection.)

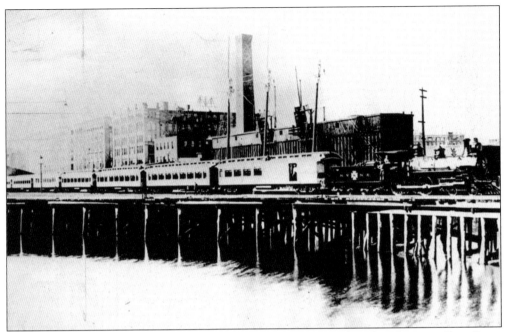

An all-white train of the New York, New Haven & Hartford Railroad crosses Fort Point Channel over the Eastern Rail Road Bridge in 1893. The elegant "Ghost Train," featuring white silk curtains and gold, plush upholstery, ran from the Summer Street Station to New York via the Air Line Railway from 1891 to 1895. The bridge was replaced in 1899 with today's Summer Street Bridge. (Boston Public Library.)

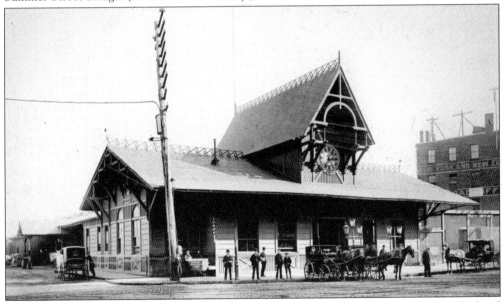

The passenger depot of the New York and New England Rail Road, pictured in 1897, faced present-day Dewey Square near Summer Street. Built in the Victorian Stick style, it had broad eaves to protect waiting passengers from the elements. Replaced by South Station in 1899, it was demolished to allow Summer Street to be extended into South Boston. (Boston Public Library.)

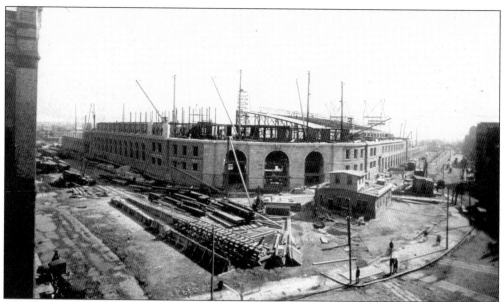

The Boston South Terminal project was undertaken by the Boston Terminal Company to consolidate existing rail service from points south of Boston. Here, the station is under construction in 1898, with pink granite shipped via rail from the Stony Creek quarries near New Haven, Connecticut, being used. Note the great train shed rising behind the arched facade. The terminal opened for business on January 1, 1899. (Author's collection.)

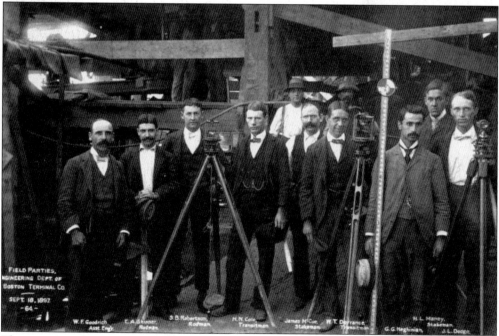

These project engineers pose for a commemorative photograph near what was the South Station field office, set up near Atlantic Avenue. They prepared and verified the surveys, elevations, grades, and distances of various components of the project. Note the lack of hard hats and safety vests! (Author's collection.)

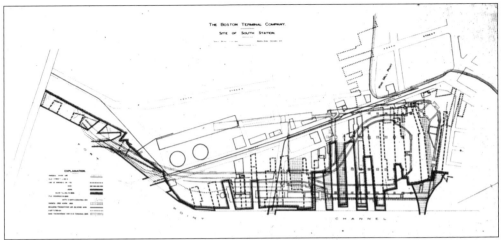

This foundation plan is shown superimposed onto the channel waterfront to be occupied by the new Boston South Terminal Project. In 1897, its technical challenges were comparable to today's Central Artery project. Note the original tunnel "turn-about" design and the various wharves that had to be filled to accommodate the station. The former Wind Mill Point is noted above.

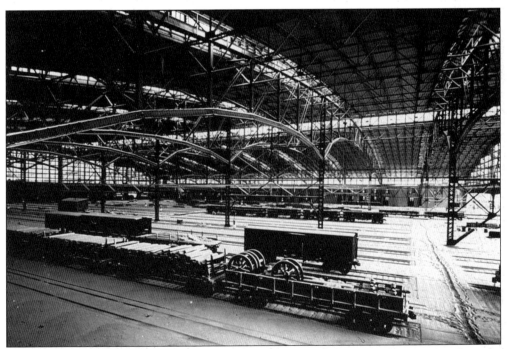

South Station featured a great train shed to protect both passengers and equipment from the elements. The shed employed steel technology used in the construction of bridges during this period. This image was captured after a blizzard swept the city. The graceful arches of this lost landmark inspired the form of the new Boston Convention and Exhibition Center, in South Boston. (Author's collection.)

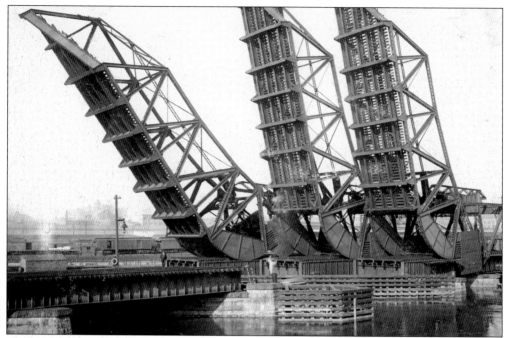

The Old Colony Railroad Bridge was a six-track, triple-leaf, Scherzer rolling lift drawbridge, built in conjunction with the Boston South Terminal project. Recently demolished, it was the largest bridge of its kind when built in 1898. This 1904 view depicts the spectacle of the bridge when opened. (Boston Public Library, Detroit Photographic Company.)

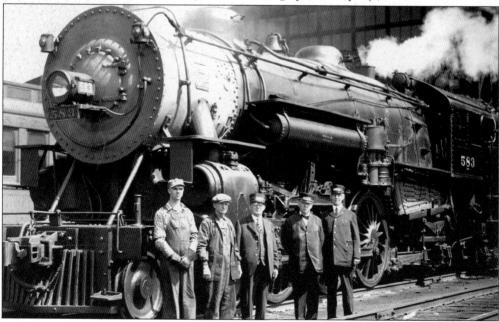

The crew of the North Shore Limited, Boston & Albany's new morning service to Chicago from South Station, poses before preparing to leave in June 1927. From left to right are fireman P. W. Roberts, engineer Austin P. Streeter, conductor T. J. Rielly, and Pullman conductors E. J. Martin and H. D. Temple. (Boston Public Library.)

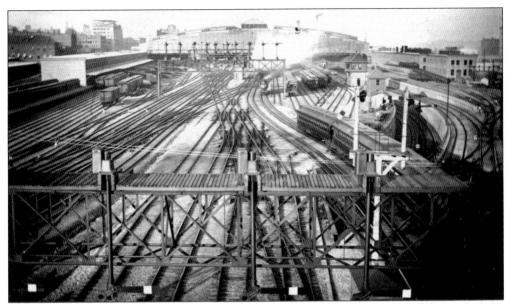

In this 1899 view, the rail yards behind the newly built South Station reveal an array of tracks, switches, signals, tunnels, and assorted Victorian-era engineering. A spectacle of technology for its time, South Station was among the most sophisticated rail facilities built anywhere. With 28 platforms, the station occupied the entire block between Atlantic and Dorchester Avenues. (Boston Public Library.)

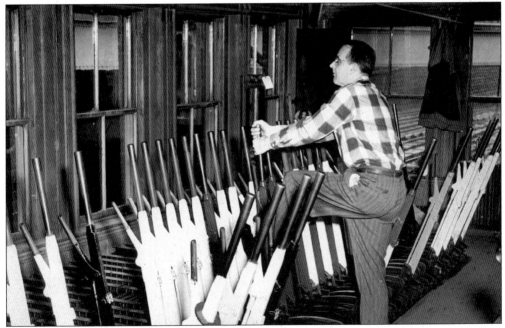

This switch operator is stationed at the Cabot Yards, near Broadway Bridge. This 1953 view provides some insight into the inner workings of the South Station switch house tower. The old manual switches required body strength to operate. These systems have been completely replaced through MBTA modernization programs. The Broadway Bridge is visible through the windows. (Boston Public Library.)

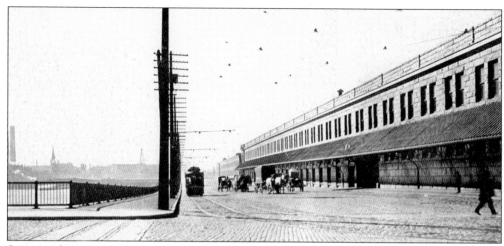

Seen in this view looking southward, the recently completed Dorchester Avenue featured trolley service connecting South Boston and Dorchester with downtown Boston. Note the two-story wing of South Station with its peripheral canopy designed to shelter passengers, luggage, and mail between transfers. Today, this site is dominated by the sprawling U.S. Postal Annex facility. (Boston City Archives.)

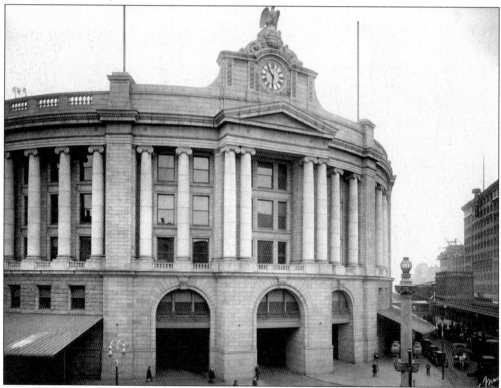

South Station was designed by the Boston architectural firm of Shepley, Rutan and Coolidge in 1897. Designed in the Neoclassical Revival style, it became the largest and busiest railroad station in the world. Its venerable Greco-Roman facade has greeted millions of travelers to and from Boston for over a century. To the right is the old Essex Hotel, on Atlantic Avenue. (Boston Public Library.)

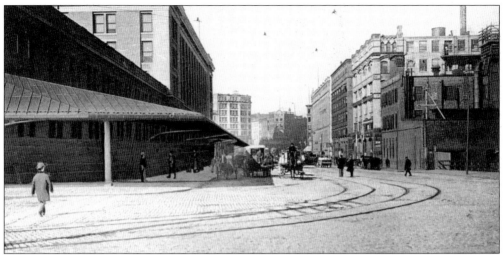

This 1902 view is toward Dewey Square from Dorchester Avenue. Note the mercantile buildings on the right. They surrounded Dewey Square and housed the leather and wool trades well into the 20th century. Boston's Leather District proper, west of South Station, is a remnant of this scene and a close relative of the Fort Point District. (Boston City Archives.)

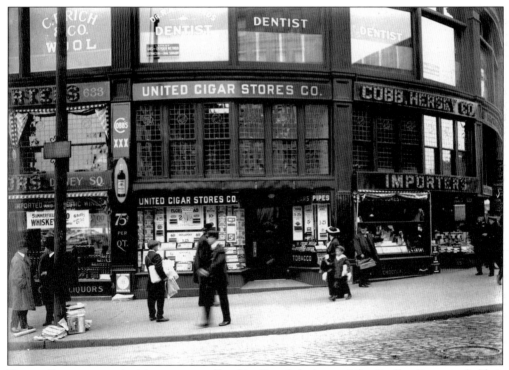

Dewey Square teemed with newsmen, "bookies," and shoppers. Like Scollay Square of old, it characterized Boston before automotive interests began sanitizing the city. This storefront is evidence of the scale now missing here. Built in 1900 and demolished in 1956 to accommodate the Central Artery, the handsome Brown Building had a curved facade that echoed the form of South Station nearby. (Society for the Preservation of New England Antiquities.)

81

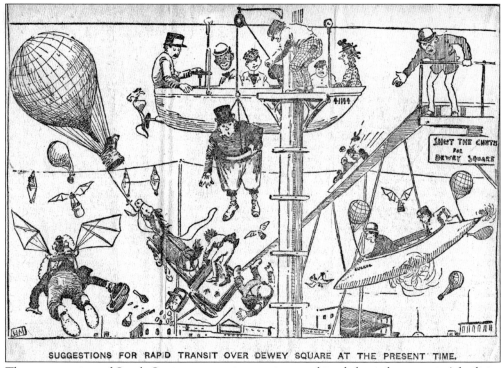

SUGGESTIONS FOR RAPID TRANSIT OVER DEWEY SQUARE AT THE PRESENT TIME.

The construction of South Station as a union station combined the rail companies' facilities into one terminus. This change, in combination with growing mercantile activity, congested Dewey Square with foot, carriage, and trolley traffic. This period cartoon illustrates one artist's vision for improving the situation. Apparently Dewey Square was a riot of movement. (Boston City Archives.)

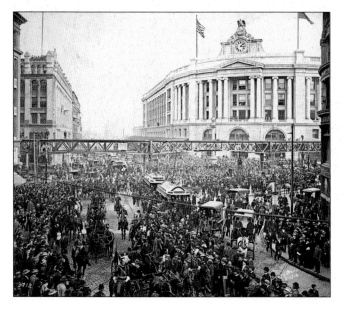

Throngs welcome Pres. William McKinley and Vice Pres. Theodore Roosevelt to Dewey Square in 1901. Note the congestion and aesthetic disruption of the Boston Elevated Railway against the monumental facade of South Station. Shortly after the station was finished, the Boston Elevated built a line from Washington Street in the South End to Atlantic Avenue and through Dewey Square to the waterfront. (Boston Public Library.)

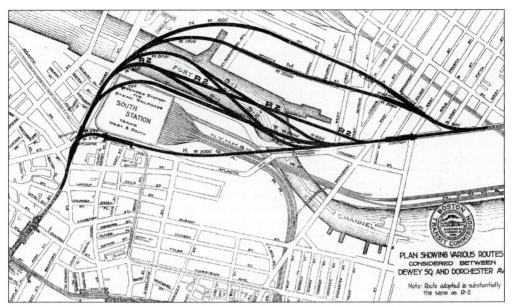

With traffic congestion in Dewey Square becoming intolerable, the Boston Transit Commission planned a rapid-transit subway extension from Cambridge through downtown Boston to Dorchester. The commission selected alignment R2, running directly beneath Fort Point Channel. Note the short-lived Atlantic Avenue Bridge extension into South Boston. (Boston City Archives.)

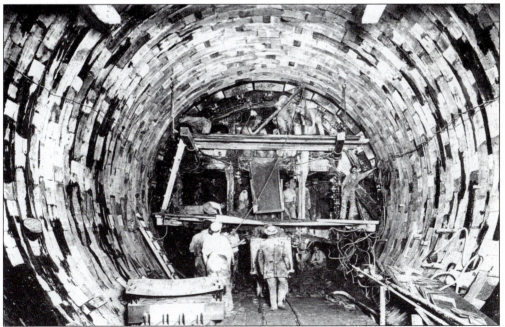

The Big Dig has its precedents. Here, these workers are seen building the new Dorchester Tunnel extension beneath the bed of Fort Point Channel (hard hats were not required in 1916). The new subway gave working men and women convenient access into downtown Boston and Cambridge. Today, this tunnel is used for the MBTA's Red Line service. (Boston City Archives.)

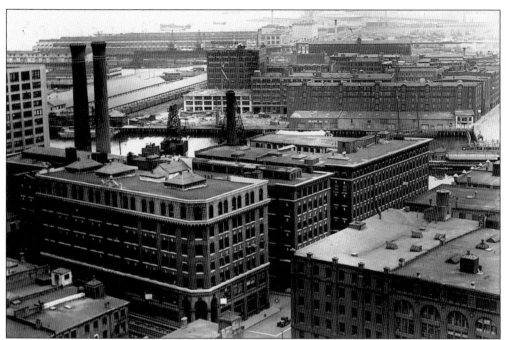

This August 1929 view looks eastward from the roof of the United Shoe Machinery Building. In the center of the photograph are, from left to right, the Russia, Graphic Arts, and Tufts Buildings. They occupy what was Russia Wharf. In 1829 alone, Russia Wharf welcomed more than 39 ships carrying imported Russian candles, soap, tallow, and millions of quills, which served as 18th-century pens. (Boston Public Library.)

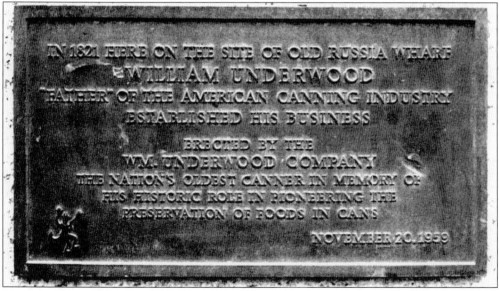

It was on Russia Wharf in 1822 that William Underwood established a food-processing firm that later gave birth to the American canning industry. This plaque on the Russia Building, affixed in 1959, commemorates Underwood's "historic role in pioneering the preservation of food in cans." (Author's Collection.)

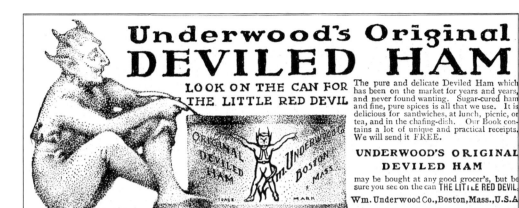

William Underwood's first product was mustard. Soon, however, he was preserving and shipping ketchup, marmalade, and cranberries all over the world in jars made by early Boston glassmakers. Underwood turned to packing products—including his famous "deviled" ham—in tin canisters. His little red devil logo remains the oldest commercial trademark in continuous use in the United States. (Vintage Ads.)

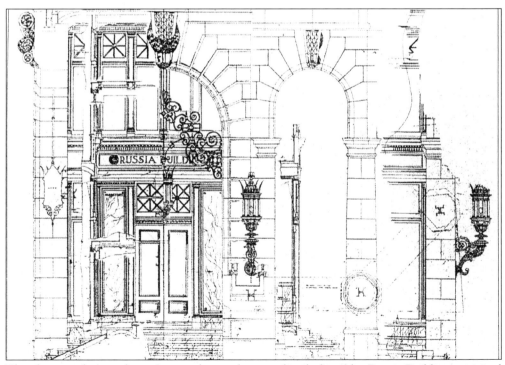

This drawing depicts the granite and wrought-iron details from the Russia Building's original 1897 plans. Designed by architects Peabody and Stearns, the seven-story Classical Revival building is constructed of buff-colored brick trimmed with terra cotta. The adjacent Graphic Arts and Tufts Buildings (also built in 1897) were designed by architects Rand, Taylor, Kendall & Stevens. (The Bostonian Society.)

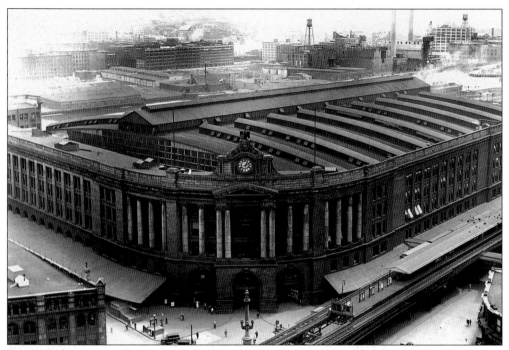

Lasting only 30 years, the giant South Station train shed, with its elaborate ribbed roof structure and vents, deteriorated rapidly. A victim of weather extremes including ice, soot, and steam, it was demolished for scrap in 1930. To protect passengers, a series of conventional platform canopies were installed. Gone was one of Boston's greatest engineering landmarks. (Boston Public Library.)

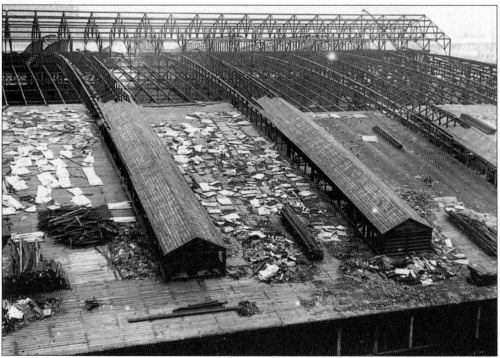

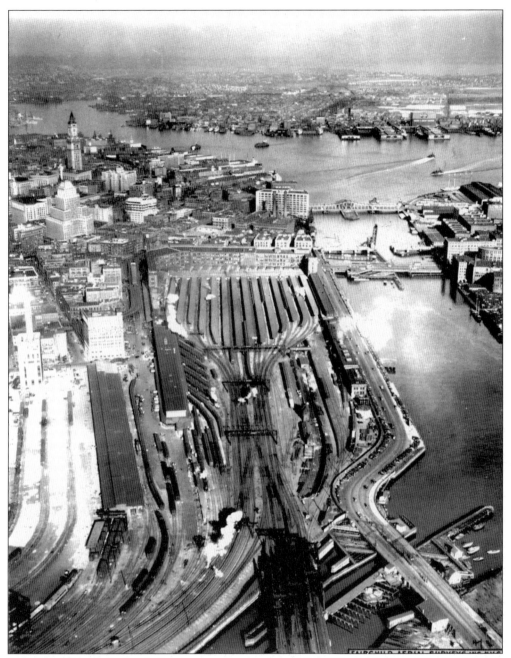

Stripped of its shed, South Station stands naked in this 1930 aerial view. The head house appears shallow without the great canopy arching behind it. To the left are the old Boston & Albany freight yards, created by filling the South Cove in 1833. Today, this area contains the highway interchange where Interstates 93 and 90 meet. (Boston Public Library.)

This sturdy triple-block building complex was located on the corner of Summer Street and Dorchester Avenue. It housed a variety of businesses, including wool and leather merchants, until demolished to make way for the Federal Reserve Bank tower in the early 1970s. Note the shade awnings, necessary before central air conditioning, and the sign proclaiming the building as home to the Boston Wool Trade Association. (Society for the Preservation of New England Antiquities.)

Erected to commemorate Adm. Richard Dewey's naval victories in the Spanish-American War, this 40-foot Corinthian column of granite featured four sculpted Roman warships protruding as lamp brackets and a single large decorative lamp above. It was the first object visitors saw when entering and exiting South Station. Neglected, the monument was dismantled for a street-widening program. (New England Historic Genealogical Society.)

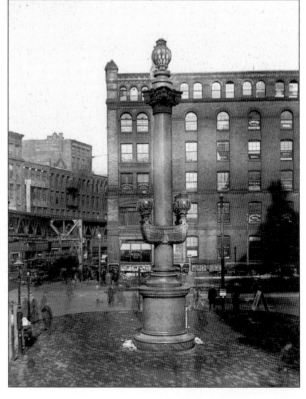

Visible from Dewey Square, the United Shoe Machinery Building is seen under construction in 1929. Designed by architects Parker, Thomas and Rice, the 20-story landmark was one of Boston's earliest Art Deco buildings and among the first towers to go up since the construction of the customhouse tower in 1915. The Wentworth Building, on the right, was demolished for the first Central Artery project, in 1956. (Boston Public Library.)

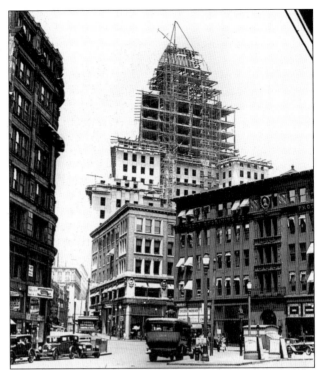

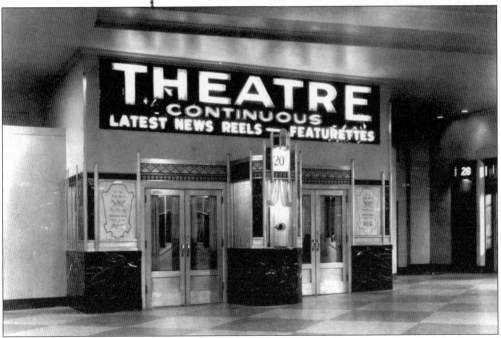

South Station offered patrons a bowling alley, a chapel, and a movie theater. This Art Deco venue featured short films and newsreels, offering travelers entertainment for a mere 20¢ as they waited for trains. Note the brass doors, frames, and embossed panels flanking the entrance. Similar Art Deco metal craft is still visible within the United Shoe Machinery Building nearby. (Society for the Preservation of New England Antiquities.)

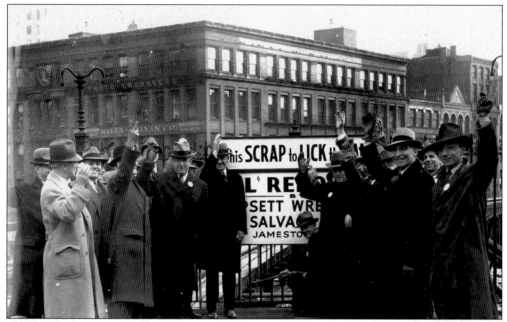

In an age prior to political correctness, these Boston Transit officials, responding to the scrap drives during World War II, give the signal for demolition crews to begin dismantling the old Atlantic Avenue elevated railway. By 1941, Boston's port activity had so declined that the transit line became severely underutilized and deemed redundant. (Society for the Preservation of New England Antiquities.)

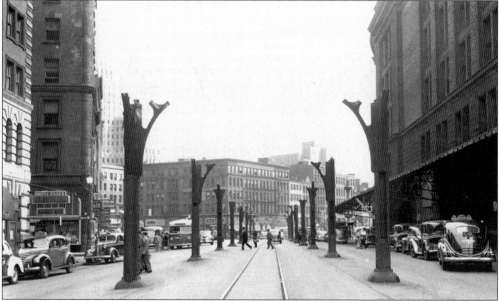

With the old Atlantic Avenue elevated removed, buildings in the heart of Dewey Square could be seen freely for the first time in over 40 years. During this period, more privately owned vehicles occupied city streets, causing a new round of traffic congestion. In just over a decade, the block beyond was demolished to accommodate the first Central Artery Tunnel project. (Society for the Preservation of New England Antiquities.)

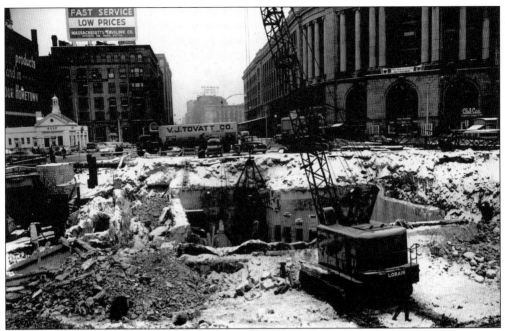

In preparation for the new Central Artery, excavation was performed to relocate the MBTA's Dorchester Transit Tunnel. Note the Gulf Station and billboards along the square and the Club Car lounge at the base of the terminal. The Boston Wharf Company sign beckons in the distance. (Society for the Preservation of New England Antiquities.)

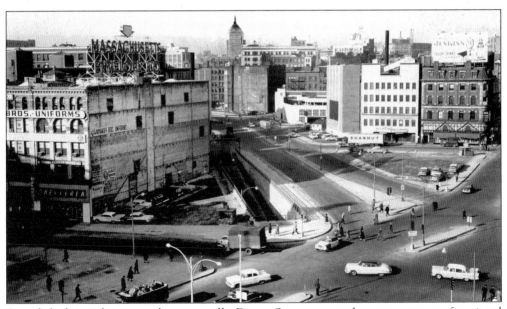

Denuded of its pedestrian-scale street walls, Dewey Square enters the expressway era functional but disfigured. In this westward view is seen the Hecht (Mass Envelope) Building, once a proud mercantile emporium and now home to the One Financial Center tower. By 1993, another round of Central Artery construction tore up this scene yet again. (George Cushing photograph.)

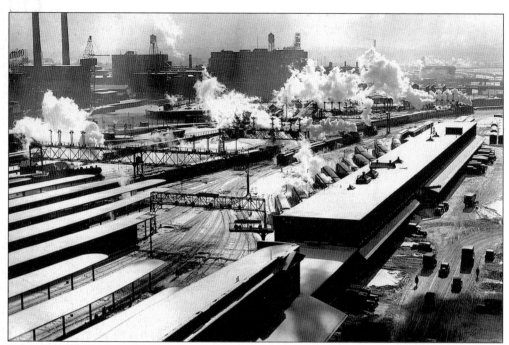

Steam billows from the locomotive yard of South Station, seen here on a winter day in 1936. The picture was taken from the roof of the Essex Hotel, on Atlantic Avenue. The Mail Express Terminals are to the right where the rail cars appear angled to the building. This facility was later replaced by the South Station Postal Annex along the channel. (Boston Public Library.)

Prior to the existence of the Interstate Highway System, long-distance mail was shipped and delivered via rail and passed by hand from train cars to wagons. In this labor-intensive work, the sacks had to be lugged off for manual sorting. Here, on December 8, 1959, a crew is tackling the day's onslaught, made larger by holiday greeting cards. (Boston Public Library.)

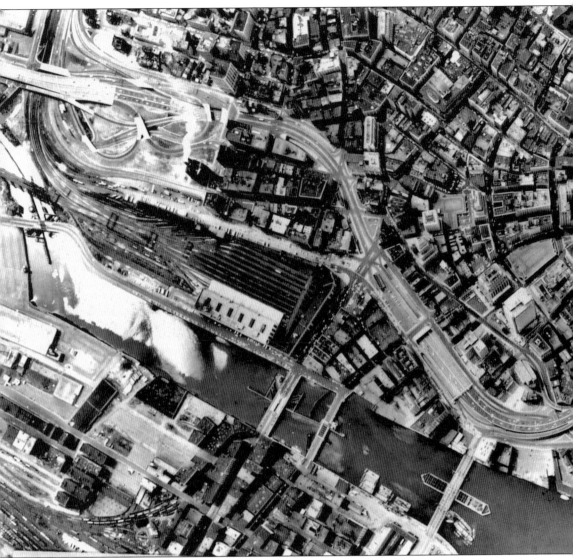

In this 1966 aerial view, the South Boston Postal Annex is seen built upon land formerly occupied by South Station passenger platforms. Slicing diagonally through the image is the Central Artery Expressway, placed underground through Dewey Square in response to protest by area residents and merchants. A harbinger for regional economic growth, the Central Artery radically and permanently altered the physical characteristics of downtown Boston.

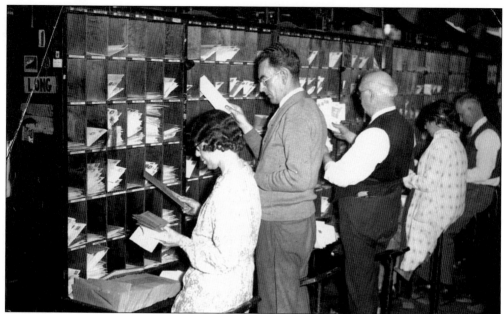

The South Station Postal Annex, along Fort Point Channel, has employed thousands of Boston residents over the generations—many of them from South Boston. These sorters are seen manually directing letters in 1932. Fast and accurate reading machines have since taken on this task. Note the unusual inclined seats assigned to each worker. (Boston Public Library.)

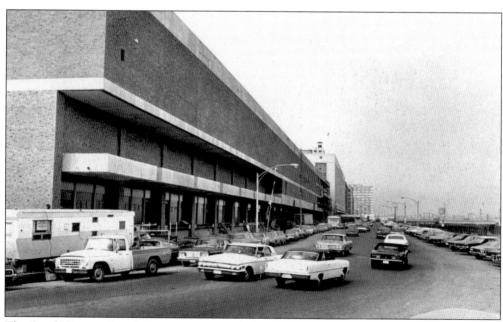

The South Station Postal Annex was expanded in the late 1960s to allow for a transition from rail to truck transfer operations. Expecting traffic conflicts along its new loading docks, the U.S. Postal Service elected to purchase Dorchester Avenue from the city. This northbound view captures the avenue when it was still a public street. (Boston Herald.)

Five
THE SOUTH BOSTON PIERS AREA

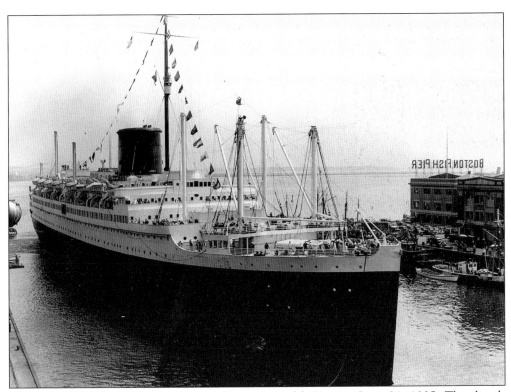

The new, 600-foot *Lafayette* arrives at Commonwealth Pier on June 21, 1935. The diesel-powered ocean liner, known for its innovative Art Deco interiors, was completely destroyed by fire in 1938 while undergoing repairs at its home port of Le Havre, France. The outer tip of the Boston Fish Pier is visible to the right. (Herald Traveler, 6/35.)

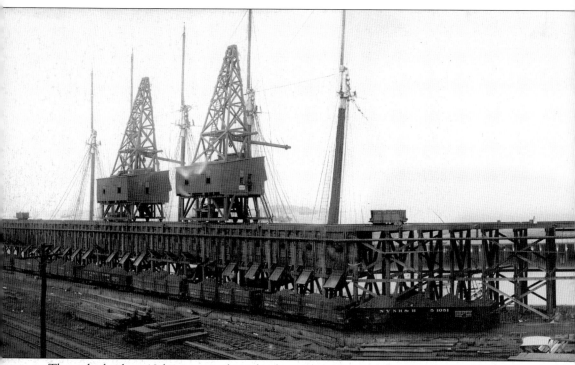

Through the late 19th century, this wharf complex imported the thousands of tons of coal annually consumed by Boston homes, businesses, and industries. The coal arrived aboard large

Bars and cafes like this one were typical among the South Boston piers along Northern Avenue. Here, longshoremen would stop for an early-morning breakfast or join other workers to sooth a day's labor. This restaurant building, converted for tourism, still exists on the waterfront today. (Boston Public Library.)

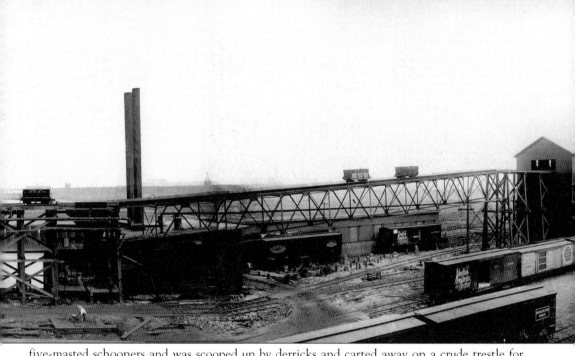

five-masted schooners and was scooped up by derricks and carted away on a crude trestle for storage and distribution. (Society for the Preservation of New England Antiquities.)

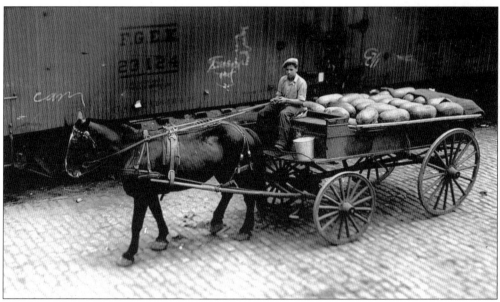

The piers area was served by a multitude of rail sidings to allow for the import and distribution of produce and other goods. Here, a wagon vendor carts watermelons to sell at nearby markets. It was not uncommon for local youths to abscond with a stray or unattended melon, often as a dare or to break up the monotony of a hot summer day. (Boston Public Library.)

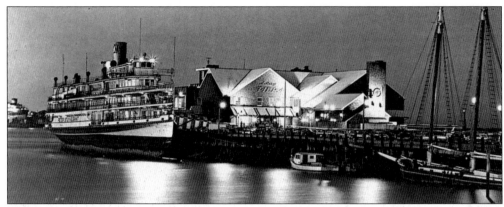

Anthony's Pier 4 Restaurant is a famous destination, retaining its title as one of the most popular restaurants in the country. Through the years, the restaurant has hosted heads of government, including U.S. presidents; religious leaders; notable artists and writers; athletes; and a virtual who's who from the entertainment world. (Athanas family.)

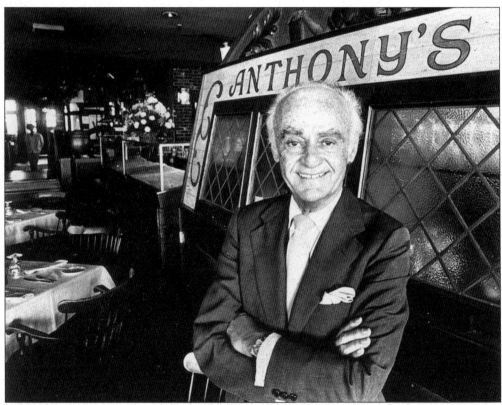

Anthony Athanas opened his flagship restaurant on Boston's Pier 4 in 1963. A son of Armenian immigrants, he ventured to the waterfront when the area was in steep decline. His bold vision of a venue with great harbor views proved to be an immediate success. Today, his four sons manage the landmark restaurant. (Herald, 12/97.)

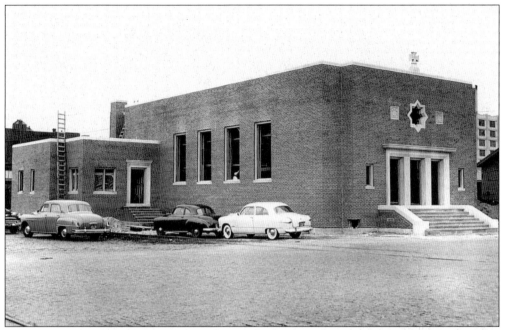

Our Lady of Good Voyage Chapel was built in 1952 on Northern Avenue to serve the fishermen of the nearby Boston Fish Pier and other mariners either stationed on the South Boston waterfront or crewing on visiting merchant vessels. Although it appears isolated today, the chapel still holds regular services. (Boston Herald, H. Stier photograph, 9/52.)

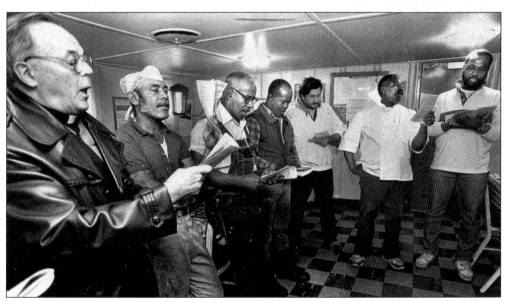

Father Phillip LaPlante of our Lady of Good Voyage Chapel makes a Christmas visit to one of the oil tankers docked in Boston. He is pictured here singing Christmas carols with some of the crew of the vessel *Montrachet*. (Boston Herald, T. Fitzgerald photograph, 12/91.)

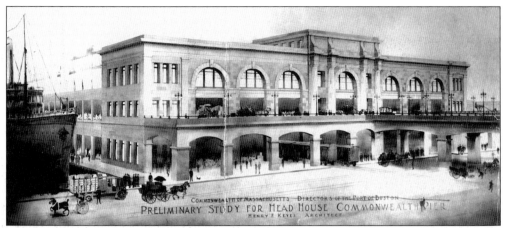

In 1911, port of Boston officials erected a new facility to handle oceangoing freight and passenger vessels entering the harbor. Built along newly filled mud flats, Commonwealth Pier was designed by architect Henry F. Keyes in the Classical Revival style. This early design featured Roman thermae windows amid the pier's hollow archways—offering a richer, more complete appearance. (Boston Herald, 3/57.)

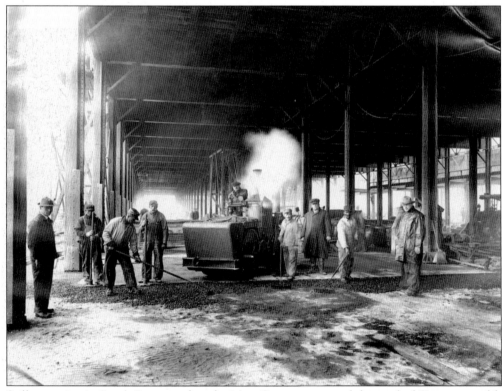

Still operating in South Boston today, the Marr Company erected the steel of Commonwealth Pier in 1911. These men are paving a new concrete floor within the new structure. The steamroller, in the center, is of the true variety. The pier's construction employed hundreds of men, many of them recently arrived immigrant laborers. (The Bostonian Society.)

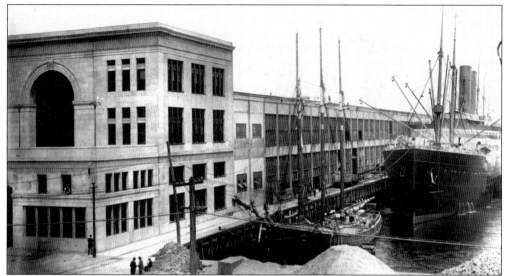

For half a century, Commonwealth Pier was New England's premier overseas–passenger ship terminal. Here, a big liner shares its berth with a smaller merchant vessel. By 1960, the success of air travel rendered the pier obsolete. By 1960, Logan Airport superceded the pier's role as an international gateway. Today, it functions as the World Trade Center exhibition hall and office center. (Boston Traveler, 12/12.)

The South Boston piers teemed with freight activity. Everything was moved on wooden palettes and by hand. Using a 2,000-pound sling, longshoremen unload the freighter *Iowan* to a second-level storage area of Commonwealth Pier. These methods were made obsolete by modern containerization facilities erected in South Boston and ports worldwide after World War II. (Boston Traveler.)

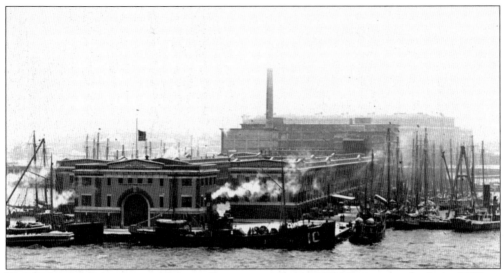

The Boston Fish Pier, viewed from the steamer *George Washington*, was built in 1912 to accommodate the city's growing fish industry. With 44 wholesale fish stores, Boston was then recognized as the world's largest fresh fish market. The fish business had been transacted at T-Wharf, near Quincy Market, but was moved here in an effort to modernize. (The Bostonian Society.)

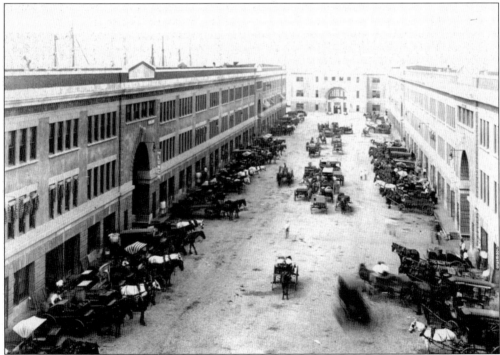

Designed by architect Henry Keyes, the Boston Fish Pier's eclectic Greco-Roman-style architecture includes two identical buildings spanning the pier's length that were used for stores and auction houses. The central administration building, notable for images of Neptune and bas-relief images of the sea, housed the Boston Fish Market Association and the New England Fish Exchange. (Boston Public Library.)

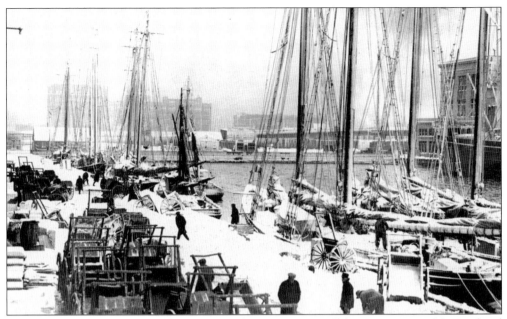

In this view looking southward toward Northern Avenue and the Commonwealth Pier head house, fishermen are seen digging out Fish Pier's outer apron after a severe winter storm. Note the rigging completely coated in ice and snow. These conditions made the winter season especially difficult and dangerous for fishing crews. (The Bostonian Society.)

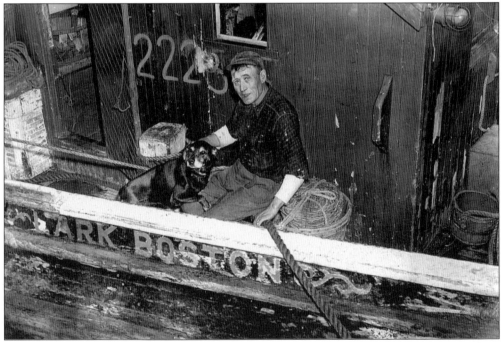

A close call, Rene Amerault relaxes aboard the trawler *Lark* with Rex, the ship's mascot, along the Boston Fish Pier. Amerault's craft withstood both shelling and machine-gun attacks from a German submarine prowling the North Atlantic. A shell hole is visible beside the old salt, who was lucky to survive. (Herald, 6/44.)

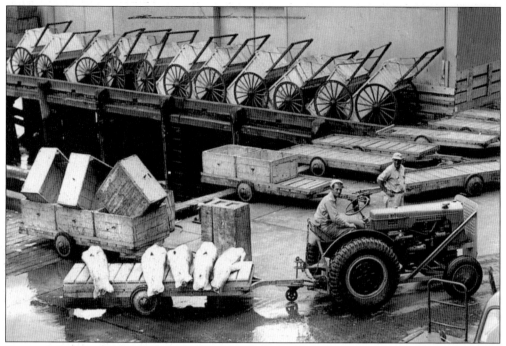

Boston fishermen landed daily with tons of swordfish. This tractor operator is hauling a ton of the New England delicacy off to the Boston Fish Pier's icing plant. Note the row of pushcarts beyond. (Boston Herald, Les Jones photograph, 7/50.)

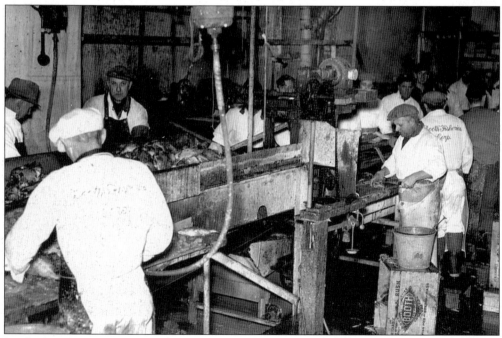

Inside the Boston Fish Pier, workers are seen cleaning and filleting the catch for consumption in the marketplace. In 1926, more than 250 million pounds of fish were distributed here, making this facility one of busiest of its kind in the world. (Boston Herald, 1/39.)

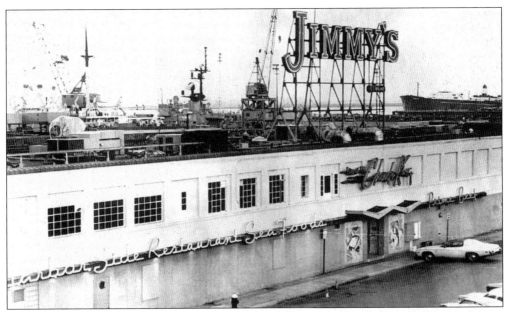

A large oil tanker is seen entering Boston Harbor behind Jimmy's Harborside Restaurant, on Northern Avenue. Jimmy's distinctive neon signs have greeted patrons for decades. On the left, behind the restaurant, is the former General Ship dry-dock and repair facility. (Herald, 4/78.)

Jimmy's is a favorite among politicians, actors, and other notables. In November 1957, owner and "Chowder King" James Doulos (standing) hosts governor's councilors and state judges as they lunch with Dan Walton (seated behind Doulos), district attorney of Houston, Texas. (Herald, 11/57.)

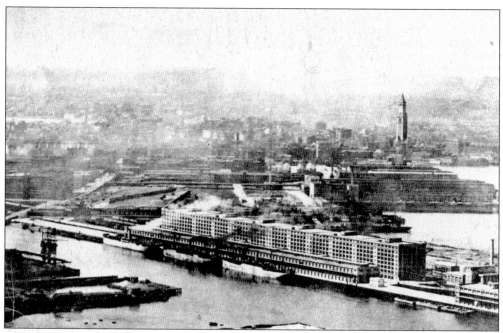

This aerial view of the Boston Army Supply Base depicts a multibuilding complex operating adjacent to the reserve channel on more than 20 acres of land. The facility was built in 1918 during World War I. The eight-story, 1.6-million-square-foot storehouse is now the home of the Boston Design Center. (The Bostonian Society.)

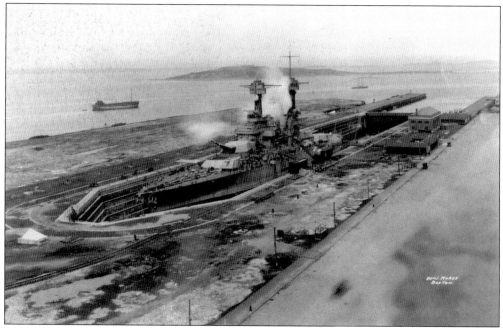

The Commonwealth Dry Dock was built in 1919. Nearly 1,200 feet in length, it was designed to hold two vessels at once. The battle cruiser viewed here is an early customer. To the right, a pump house drained seawater from the dock, as a mammoth steel door kept the ocean out. (Society for the Preservation of New England Antiquities.)

Curious reporters surround this British army tank, shown being tested within the New Haven and Boston & Albany rail yards behind warehouses on Fort Point's Midway Street. The tank is covered with the graffiti of English servicemen who have shipped the steel armament as part of a government loan program. (Boston Public Library.)

The U.S. Army Supply Base, in consort with the Charlestown Navy Yard some three miles away, bustled with activity during World War II. Here, a security vessel is seen shuttling personnel. In the background on the main pier is a former base administration building. (Herald, 8/50.)

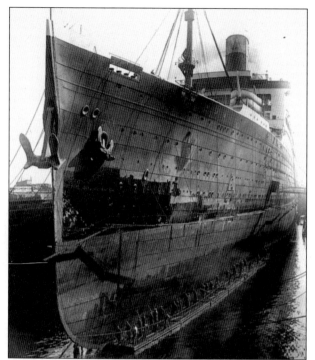

The SS *Leviathan* visits Commonwealth Dry-Dock for refurbishing in March 1930. Here, workers apply fresh paint after having scraped the barnacles off the hull. Built in Germany as the *Vaterland*, the ship was seized for use as a troopship by the U.S. government during World War I. It returned to commercial service between New York and Europe in 1922 and ended service in 1934. (Boston Herald, Associated Press photograph, 3/30.)

After running aground off the coast of Martha's Vineyard, the *Queen Elizabeth 2* undergoes repair in the Commonwealth Dry-Dock (later named Dry-Dock No. 3). The vessel's looming appearance presented a rare, eye-catching event that attracted hundreds of marine-wise South Boston spectators. (Boston Herald, G. Martell photograph, 4/93.)

Six
FORGING A FUTURE
THE RECENT PAST

This 1970 rendition shows a new Federal Reserve Bank tower designed by architect Hugh Stubbins and a new South Station Terminal complex designed by architect Jose Luis Sert. Another tower, seen beyond, was built by the Stone and Webster Corporation as a mid-rise building. Stone and Webster designed much of the Boston subway system early in the century. (Herald, 1/70.)

Edward Logue, Boston Redevelopment Authority director and chief planner throughout the 1960s and early 1970s, oversaw the redevelopment of much of Boston's central business district. Here, Logue presents a rendering depicting development concepts for Dewey Square, including a model for a new stadium complex projected for derelict land along Fort Point Channel. (Herald, 2/66.)

This model shows the Federal Reserve Bank as it was built. The bank's unique washboard facades and reflective aluminum skin are visible for miles across Boston Harbor. The bank's construction was a prime catalyst for new investment in Dewey Square and across the Fort Point Channel into South Boston. (Boston Public Library.)

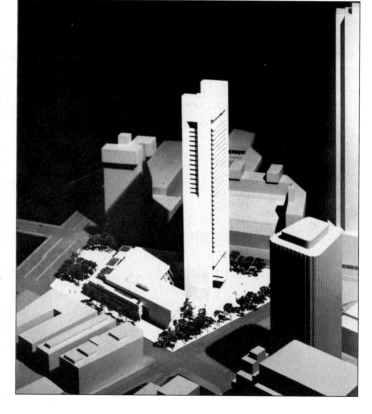

South Station was placed on the National Register of Historic Places in 1975. Since then, MBTA and federal transportation authorities have been planning major renovations to preserve the station head house and allow for phased increases in train, bus, and subway service. Their concept includes future air rights development over the station. The project has brought great vitality to the foot of Fort Point.

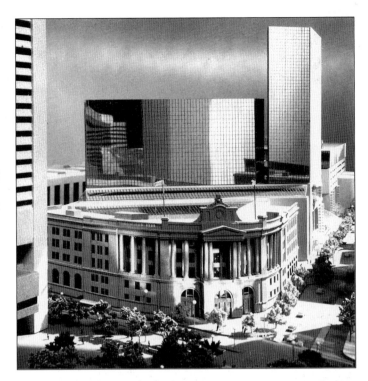

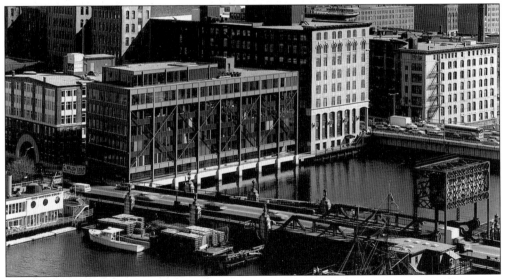

Completed in 1984, the building at 303 Congress Street was the first new commercial structure built in Fort Point in 70 years. It accelerated new investment on the South Boston side of the channel. Its unique facade was inspired by the counterweight of the nearby Congress Street Bridge. Short-lived, the building was demolished in 1995 after its foundation failed. It was rebuilt with changes to its facade in 2000. (Finegold-Alexander Architects.)

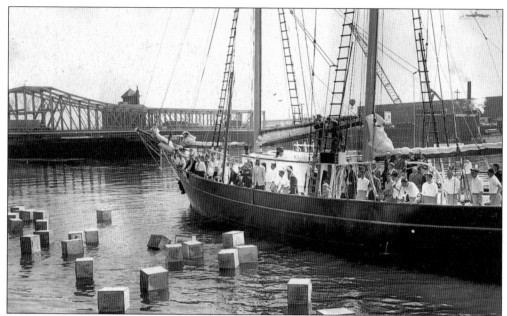

Modern reenactments of the Boston Tea Party have been a Boston custom for generations—often to protest contemporary issues. The chests on this occasion were thrown overboard from a vessel berthed along the Congress Street Bridge near the site of Griffin's Wharf on May 5, 1957. (Boston Herald, G. Hoyt photograph.)

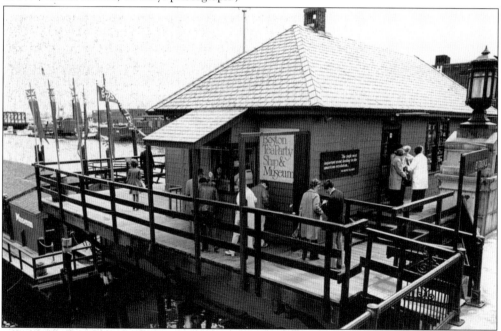

Opened in time for the nation's bicentennial celebrations, the Boston Tea Party Ship and Museum became a popular tourist destination, contributing substantially to the area's renewal as a lively annex of the city's historic downtown waterfront. The museum occupies the former operator's house of the Congress Street Bridge. A complete renovation and expansion of the museum is under way. (Boston City Archives.)

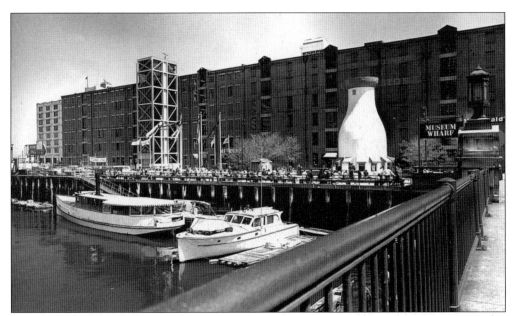

The former Atlas Stores wharf was renovated to accommodate a new Children's Museum of Boston. Opened in 1979, Museum Wharf was pivotal in the redefinition of Fort Point as a popular destination for families seeking recreation, education, and entertainment. The children's museum thrives here today, with plans to expand along a renovated boardwalk waterfront. (Boston Herald, 5/81.)

Permanent interactive exhibits for children and their families are the major attraction at the children's museum. Exhibits have ranged from a Tokyo subway mock-up to visiting theater troupes. Here, three-year-old Kiki Johnson emerges with her mom through an exhibit on the underground workings of the city. (Boston Herald, K. Twombley photograph, 3/84.)

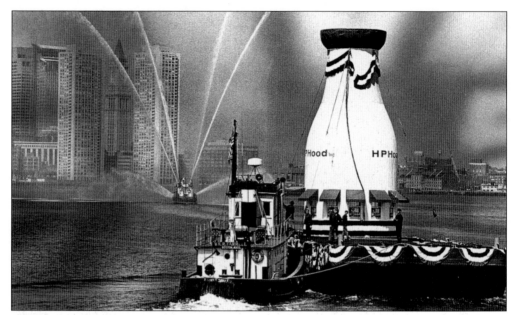

In 1977, the H. P. Hood Company donated funds to Museum Wharf for the purchase and refurbishing of this 40-foot-high milk bottle. Originally an ice-cream stand, the wooden structure was built in the early 1930s in Taunton. Here, a tug, escorted by the festive spray of fireboats, nudges the bottle to its new home on Fort Point Channel. (Herald, 4/77.)

Internationally famous Boston Pops conductor Arthur Fiedler was a firefighter's friend and a collector of department paraphernalia. Here, in June 1978, Fiedler participates in Fort Point's renewal by accepting the city's deed to the old Congress Street Fire Station from Mayor Kevin White for the Museum of Transportation, then located at the Museum Wharf. The firehouse remains a museum today. (Herald, 6/78.)

A critical force for renewal in Fort Point came from the influx of artists who saw in the area's numerous warehouse structures affordable, ample spaces in which to work. This postcard proclaims the vitality of the Fort Point Arts Community (FPAC). Founded in 1980 by artist Susanna Schell and photographer Larry Maglott, FPAC sponsors group exhibitions and provides information vital to neighborhood issues. (Felice Regan, graphic artist.)

Artists David Brown and Rebecca Dwyer were among the early artists to move into Fort Point. This studio is typical of the spaces found throughout the district. For 25 years, the Fort Point Arts Community has sponsored an Open Studios event, inviting the public to view and purchase the artists' works and showcasing their creative contributions to the city's culture. (Boston Herald, R. DeKona photograph, 7/90.)

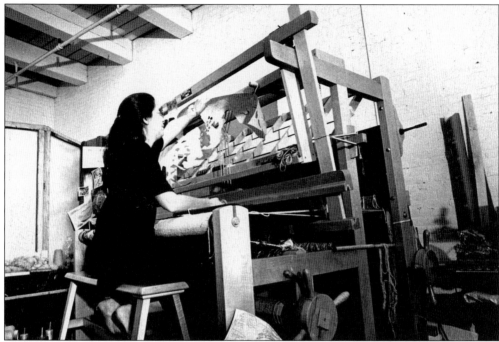

Fort Point artisans range from painters, potters and sculptors to graphic artists, photographers, architects, and furniture designers. The district is an incubator for small businesses—an attribute worth maintaining as the area evolves under corporate development pressure. In this image from the mid-1980s, Judy Berman, a Fort Point weaver, practices the ancient craft on her loom.

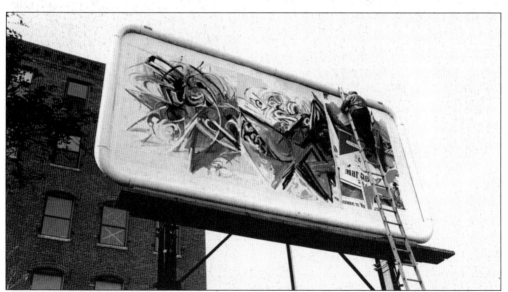

In the mid-1980s, the Fort Point Arts Community offered grants for the creation of billboard art within the district. Here, a workman affixes a painted image by Paula Savarino to a board near her studio at 249 A Street. For decades now, Fort Point artists have impressed observers with planned programs and through guerrilla actions in Fort Point and citywide. (Kathy Chapman photograph.)

Fort Point has served as a base for Boston's community of professional studio photographers. Artist-photographer Kathy Chapman, who has maintained a studio on Summer Street for 25 years, has seen many artists thrive in Fort Point over this time. She is a witness to the area, photographing its transformation from its desolate, gritty "scene" days. (Christopher Harting photograph.)

In the late 1970s, the Peter Dayton band and others frequented Fort Point to entertain audiences. The venue, at times, offered a popular night alternative to clubs like the Rathskeller in Kenmore Square. Here, the party takes over after a fashion show at a gallery at 354 Congress Street, where owners Helen Shlien, Bess Cutler, and Pat Stavoritis pioneered Fort Point's fine art scene. (Kathy Chapman photograph.)

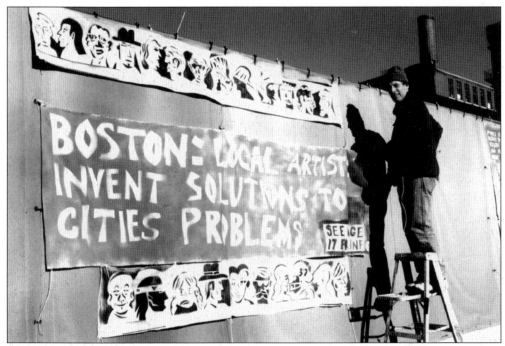

Jerry Beck, seen here in 2000 promoting the benefits of the artist presence in Boston, founded the Revolving Museum in 1984 with an art installation in 12 abandoned railroad cars on Fort Point's Fan Pier. The work marked the beginning of the museum's focus on the transformation of public spaces into innovative visual and performance art. In 2002, the museum relocated to Lowell. (Kathy Chapman photograph.)

Since 1977, the Mobius Artist Group has incorporated a wide range of visual, performing, and media arts into innovative live performance and installation works. Founded by performance artist Marilyn Arsem in 1980, the group became the nonprofit Mobius Inc. In this image, member artists Milan Kohout and David Franklin perform *Flying & Flowing,* an essay on communication through dominance. (Bob Raymond photograph.)

Produced by Boston artist Sidney Hurwitz in 1974, this print depicts the Old Colony Railroad Bridge over Fort Point Channel. The massive bridge, with its complex skewed structure and huge concrete counterweights, held a fascination for area artists. In 1995, the works filled the gallery of the Federal Reserve Bank when compiled into a popular retrospective exhibition entitled The Artist and the Artifact. (Courtesy of S. Hurwitz.)

In the spring of 2002, Fort Point artist Christina Lanzl organized A Fort Point Vision for Public Art, a partnership with Ricardo Barreto of the Urban Arts Institute at the Massachusetts College of Art and Jed Speare of Mobius. Sponsored by the Fort Point Cultural Coalition, the event presented the aspirations of Fort Point artists and residents to create permanent and temporary public art and new civic spaces in the district. (Graphic design by Barbara Hurley.)

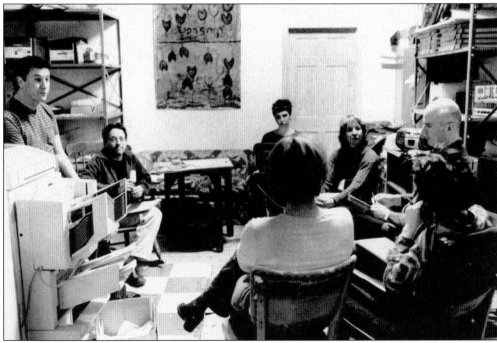

Here, Fort Point resident and artist Steve Hollinger (second from the left) leads a discussion on real-estate development issues within Fort Point. Hollinger, planner Jon Seward, and others founded the Seaport Alliance for a Neighborhood Design (SAND) to serve as a clearinghouse for information vital to the community's planning and zoning concerns. (Kathy Chapman.)

In spring 2001, Fort Point artists Lisa Greenfield and Jennifer Moses commandeered the sidewalks of the Summer Street Bridge with an installation of lush, green sod. The visually striking work was a commentary on the dearth of green space planned for an increasingly residential Fort Point neighborhood. Featured on the front page of the *Boston Globe*, it prompted city planners to allocate ample open space as a critical component in Fort Point's future. (Jeff Heyne photograph.)

The new Court Square Press condominium complex features a large cylindrical atrium designed to recall the industrial architecture of nearby Fort Point Channel. It contains more than 200 units of new housing in converted industrial space. The Macallen Company, makers of electrical supplies, built the factory between Broadway and West Fourth Street in 1906. Later, it housed the Court Square Press Company—hence its name. (Author's photograph.)

Studio Soto, on Melcher Street, captures the vitality with which the arts are celebrated in Fort Point. The gallery opened in 2000 as a forum for artists' dialogue and ideas. Other galleries have included the Little White Box, the Lab, and the Coal Room, run by the Revolving Museum. The popular FPAC Gallery, at 300 Summer Street, presents numerous shows each year and showcases Fort Point's local talent. (Gustavo Soto-Rosa photograph.)

These students and staff proudly pose before the new headquarters for Artists for Humanity on A Street. The nonprofit organization develops the creative potential of at-risk youth. Founded in 1991 by artist-educator Susan Rogerson, Artists for Humanity "promotes art as a powerful source for social change and creative entrepreneurship." Its new sustainable "green" building is an affirmation of the future of the arts in Fort Point.

At the podium on July 17, 2003, Mayor Thomas M. Menino announces a plan to develop artist live-work studios along Midway Street in Fort Point. The project is a joint venture of Fort Point Development Collaborative and Keen Development Corporation. The collaborative's Anita Lauricella and Cheryl Forté have spearheaded the project with plans that include new galleries and theater venues. (George Vasquez photograph.)

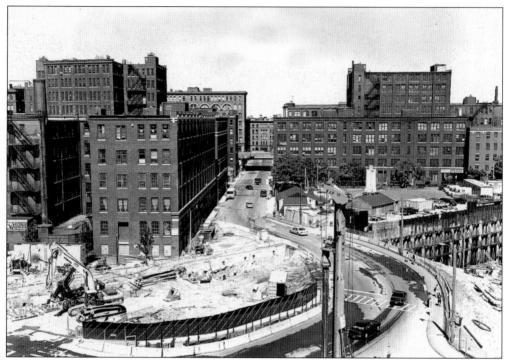

Pictured in this view looking northward in 2002 is the construction of the new Interstate 90 highway extension into Fort Point. The project had area residents dodging cranes and crews for close to a decade. This and other images by resident artist and photographer Don Eyles document the scale of the mammoth project. Note the depth of the sheet piles holding back the earth and the temporary swerve of A Street.

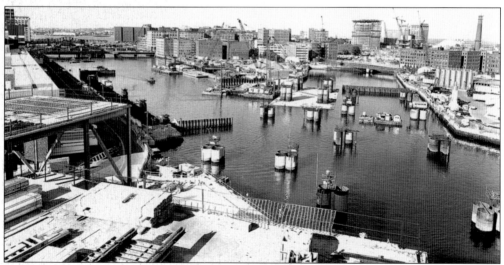

Seen here are the immersed tunnel tubes laid on the bed of the Fort Point Channel to link Interstate 90 (Massachusetts Turnpike) to Fort Point, South Boston, and the Ted Williams Tunnel beyond. The tunnels were cast nearby and floated to their final location. This view is from the peak of a new landmark vent building, constructed over the tunnel. Note the mid-rise office construction in the distance. (Don Eyles photograph.)

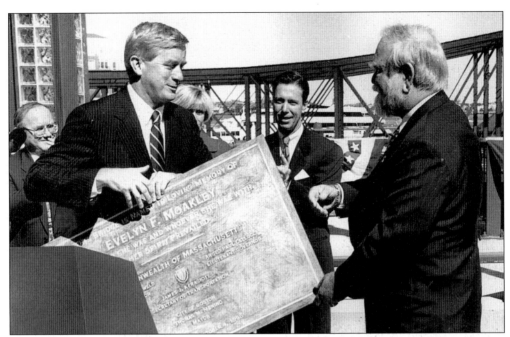

In an October 1996 ceremony, U.S. Rep. John Joseph Moakley accepts a plaque from Gov. William F. Weld renaming the new Northern Avenue Bridge in honor of the congressman's late wife, Evelyn. In the picture behind Weld and Moakley are, from left to right, city councilors James Kelly and Peggy Davis Mullen, and state senator Stephen F. Lynch. (Boston Herald, C. Ackerman photograph, 10/96.)

U.S. Rep. John Joseph Moakley was honored just prior to his death when in April 2001 the new federal courthouse on Fan Pier was named in his honor. Moakley fought hard for South Boston. His decades of service brought jobs and aid to thousands. A key advocate for the Boston Harbor cleanup, he helped secure funding for the Central Artery Tunnel and Silver Line Transitway projects, as well as the courthouse and its surrounding waterfront park. (Robert Souther photograph.)

This image captures the character of another favorite Fort Point restaurant, the Barking Crab, a casual-dining seafood restaurant on Northern Avenue. It features outdoor accommodations beneath a large tent and its clam shack appearance make it an extremely popular waterfront destination. "The Crab" also features a marina and fish market. (Author's photograph.)

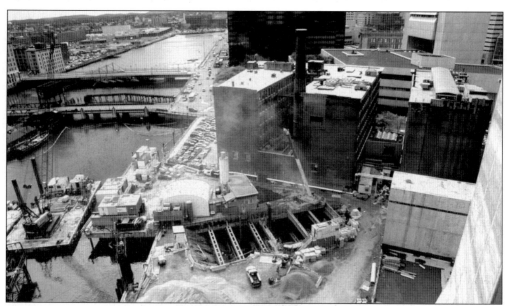

Shot in October 2002 by photographer Robert Souther, this view from the peak of a Central Artery Tunnel vent stack on Atlantic Avenue documents construction of the new Silver Line transit tunnel beneath Russia Wharf from South Station to the South Boston Piers area. Eventually, the line will connect Roxbury and Boston's South End directly to Fort Point and its surrounding area.

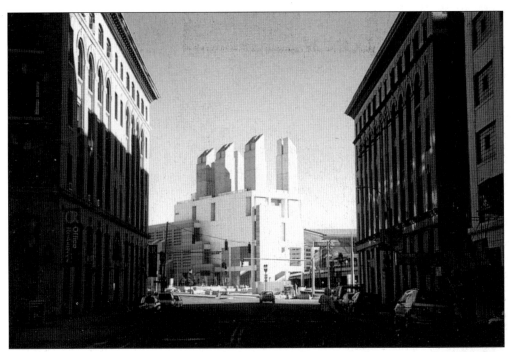

Boston has way of contrasting the old with the new. In this view, looking eastward on Congress Street, a vent building over the new Interstate 90 access tunnel is situated at an angle to the street grid. Designed by Wallace Floyd Associates to circulate the tunnel's air, the building stands in sharp contrast to the century-old wharf warehouses before it. (Author's photograph.)

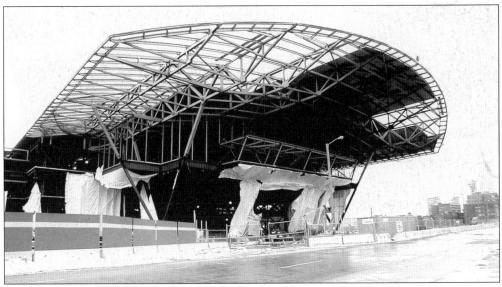

The mammoth new Boston Convention and Exhibition Center, large enough to hold three DC-10 aircraft, will transform the South Boston waterfront. Here, the center's steel skeleton looms over Summer Street as a beacon for future waves of convention commerce. The slick, $800 million center will present a fresh new face to Boston and the world. (Robert Souther photograph.)

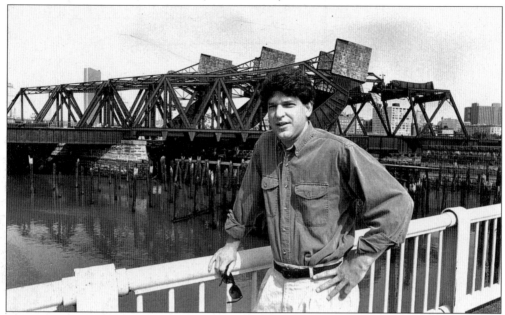

The Old Colony Railroad Bridge was demolished in 1999 to make way for the Interstate 90-turnpike tunnel extension into South Boston. The author, seen standing before the bridge in June 1992, is working with Boston artist Ross Miller and Massachusetts Turnpike officials to retain sculptural elements of the bridge for installation as industrial artifacts along a new Fort Point Channel Harborwalk. (Boston Herald, J. Davis photograph.)

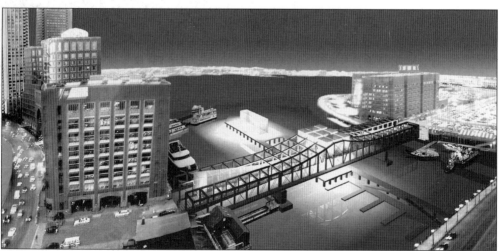

No other Fort Point icon better embodies the district's maritime transportation past than the Old Northern Avenue Bridge. Over the past decade, interested citizens have worked tirelessly to convince the city to retain the bridge as part of the Boston Harborwalk system. Mayor Thomas M. Menino and his public works commissioner, Joseph Casazza, should be applauded for exploring this recent and stunning adaptive reuse proposal with Swartz Silver Architects of Boston. (Author's collection.)